PREFACE

I was teaching my eighth consecutive pre-college program (a month-long summer course for high school seniors interested in attending an art college) and was exhausted and bleary eyed when I received an email from Victoria Craven about writing a book on illustration. Thinking this was a scam, I nearly deleted the email. Luckily, I opted to get some sleep first and reread the email the next day. Upon realizing that this was, in fact, an excellent opportunity, I quickly arranged to speak with Victoria to hear more. Then it dawned on me—I had no idea what I was doing. I'd never written a book. But after some cold logic and gentle persuasion, I understood that all I had to do was put on paper all the things I'd been yammering at my students about all these years. I just had to write about illustration, which, apart from baseball, serial killers, and old television shows, happens to be my favorite subject.

I don't consider myself a teacher. Not a real one, anyway. My sister and sister-in-law are real teachers. I'm just an illustrator who has had the good fortune to teach a subject that I'm passionate about. It's a great privilege to be given the opportunity to talk about a topic you love to a class full of interested students. Somebody needs to shout about the wonders of illustration. It might as well be me—I'm super loud.

For a long time, it's been fashionable for the art snobs to look down on illustration. It's a working art. It serves a purpose. Unlike "fine art," illustration isn't about navel gazing or finding greater truths in a tube of paint. It's not for diletantes or bored socialites. Illustration is an art and a profession. Being an illustrator means working with art directors and clients in a collaborative environment. It means communicating a concept to a larger audience. It means problem solving, trying to find the gag or punch line or trick to the piece. Illustration is working on tight deadlines. Illustration is telling a story visually. Illustration is a white-knuckled thrill ride... OK, I may have oversold that last one, but it is an awesome job; if you can't be passionate about illustration, do yourself a favor and become a CPA. And by the way, the next time some ivory tower art school professor mouths off about illustration being a low art, ask her what is the biggest department in the school is (hint: it's almost always illustration). Then ask her how solvent the college would be if the illustration department didn't exist. That should shut her up.

I hope that this book allows me to help you better understand illustration as an art and as a profession. I'd be thrilled if you, the person reading it right now (but come on, who reads the preface?) is inspired to join the swelling ranks of professional illustration. But even if you don't, I hope that reading this book will at least give you some insight into a highly visible, yet somewhat hidden, art form. Maybe the next time you see a movie poster, book cover, or playbill you'll really look at the image and appreciate the way the story is being communicated. And if not, at the very least, I hope that displaying this book on your shelf makes you look smarter to your houseguests.

Now read on and enjoy! I command it!

CONTENTS

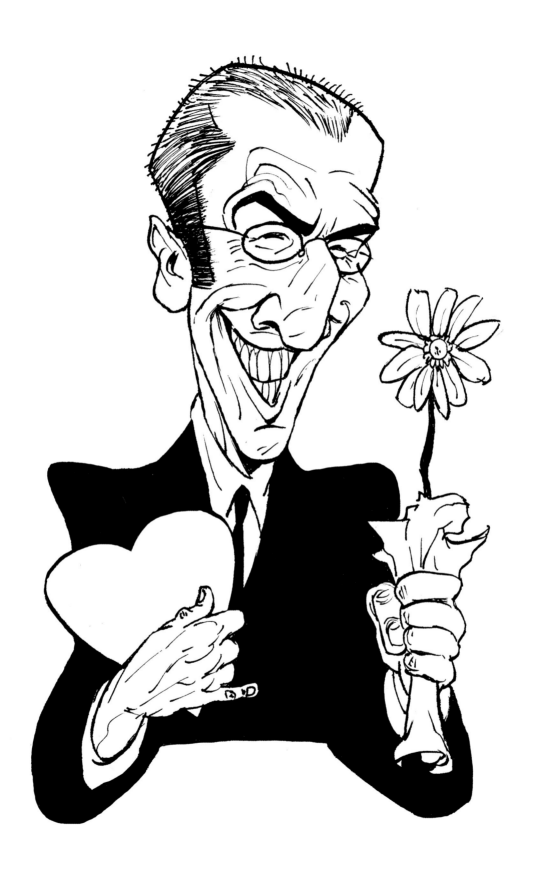

INTRODUCTION

Seduced by Illustrations

MUSEUMS ARE WONDERFUL. Everyone should visit them. But let's face it: most people probably aren't initially exposed to art through museums. I suspect that folks are more likely to first come in contact with visual art via cartoons, advertisements, comic books, newspapers, magazines, and movie posters. So while museums are amazing, magical places, it's the good old, unsung, everyday illustration that has the best chance of turning a young mind on to the world of visual arts.

Think about it: What was the image that seduced you as a kid? What picture first grabbed you by the eyeballs and got its hooks into your brain? Was it an illustration from a children's book like *The Wonderful Wizard of Oz* or *The Cat in the Hat*? Was it a movie poster? An album cover? A soft drink ad? Maybe it was a Frank Frazetta barbarian you saw in a magazine? Or did you fall prey to the charms of a Hanna-Barbera cartoon character like Scooby-Doo? Whatever the vehicle, chances are that at some point you picked up, walked by, or stumbled across an illustrated image that pulled you to it like a siren, and your eyes have been addicted ever since. That's the power of illustration.

Look at us! Talking about illustrations already—and you're hardly a page into this book. Before we dive in too deep, though, let's look at some examples of the kind of work you may have encountered early on. As with any art form, illustrations are as varied as

the artists who create them. So consider this a short introduction to the art of illustration. I hope it gets you thinking about the scope of the medium.

Let's start with Brian Sanders—a true illustration icon. Whether you were a Mod chick on London's Carnaby Street, a hippie on the Sunset Strip, or an ad man on Madison Avenue, you couldn't avoid Sanders illustrations during the 1960s and 1970s. His images appeared in magazines, on book covers, and in advertising, where he set a new standard with his incredible style and energy. His work is so identified with the "Swinging Sixties" that the producers of *Mad Men* hired Sanders, then 75, to illustrate the advertising campaign for that TV show's sixth season, in 2013.

The piece AT RIGHT is immediately recognizable as a Sanders illustration. The movement, bold color choices, interesting composition, and unique treatment of negative space take what could be a very static piece—just a snapshot of an everyday event—and imbue it with an incredible sense of life. It practically crackles! A master storyteller and consummate pro, Sanders created a number of signature styles while still meeting the needs of each assignment. (We'll revisit this piece later, in the chapter on mediums.)

To come closer to the present, take a look at the piece by Greg Spalenka OPPOSITE LEFT. Spalenka's work

BRIAN SANDERS, *BILLINGSGATE MARKET LONDON*, MIXED MEDIA. COURTESY OF THE ARTIST.

has appeared in magazines, books, and other media since the early 1980s. Whether he's doing something brooding or lyrical, Spalenka uses texture, color, and light as well as any illustrator before or since. Regardless of the subject, his work has a beauty and a passion that grabs the audience's attention—and keeps it.

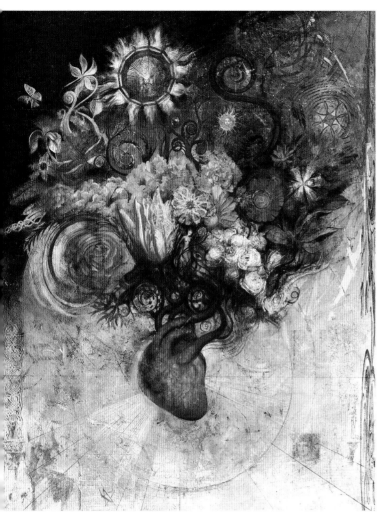

GREG SPALENKA, *ART HEART,* MIXED MEDIA (GRAPHITE, COLLAGE, ACRYLIC, AND OIL) ON BOARD, AND DIGITAL. COURTESY OF THE ARTIST.

MAXFIELD PARRISH, *THE TRAMP'S DINNER,* COVER OF *COLLIER'S WEEKLY,* NOVEMBER 18, 1905, OIL AND CHARCOAL ON PAPER MOUNTED ON CARDBOARD. DELAWARE ART MUSEUM, SAMUEL AND MARY R. BANCROFT MEMORIAL, 1935.

And now let's take a few steps back in time, to look at a piece by the great early-twentieth-century illustrator Maxfield Parrish. Parrish's cover for *Collier's Weekly* magazine, ABOVE RIGHT, demonstrates the beauty of his work. The mastery with which he manipulates the elements in the image—palette, style, use of light, composition, and the subject's expression and body language— are so marvelous that they elevate this common, shabby tramp, turning him into a character of nobility, grace, and humanity. Even with this disheveled fellow as the subject, the viewer can see the wonderful sense of romance that defines Parrish's work.

Of course, not every illustrator is a Maxfield Parrish. There's a long, proud tradition of illustrator gut-punchers. Take the piece LEFT, by the young illustrator Jimmy Giegerich. Giegerich's work is crude, rude, in your face, and fun. It has such an amiable spirit that even if his characters are sweating, grunting, bleeding, exploding, or spewing something vile from an odd orifice, they are depicted with such joy that it's hard not to be captivated.

And while we're on the subject of diversity in illustration, take a gander at the piece OPPOSITE LEFT, by Warren Linn. Clearly, Linn isn't afraid to experiment stylistically. Like Brian Sanders, he gets amaz-

JIMMY GIEGERICH, *THE CUTE ONE,* INK AND DIGITAL. COURTESY OF THE ARTIST.

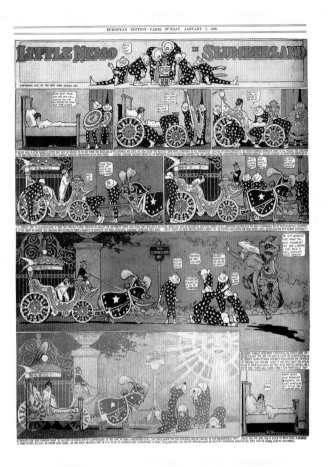

WARREN LINN, *ST. AMBROSE UNIVERSITY,* SCRATCHBOARD AND COLLAGE. EXHIBITED AT THE WARREN LINN SOLO SHOW AT ST. AMBROSE UNIVERSITY, DAVENPORT, IOWA, 1989.

WINSOR MCCAY, *LITTLE NEMO IN SLUMBERLAND,* STRIP FROM JANUARY 7, 1906.

ing movement in the image. The stark black and white really pop the character, and the collage effect reinforces his concept. It's still and dynamic at the same time. Beautifully chaotic.

Winsor McCay, by contrast, was a master of whimsy. An animator and cartoonist, he's probably best remembered for his early comic strip, *Little Nemo in Slumberland,* whose stories take place in the dreams of its young

protagonist. McCay was unabashed about letting his imagination run wild. And the drawings are exquisite, as you can see from the example ABOVE RIGHT.

This is just a small sampling of what's out there. Are your eyes up to the challenge? Does your brain have enough room to cram in even more amazing images? Well then, what do you say we jump into the first chapter and talk about what an illustrator is?

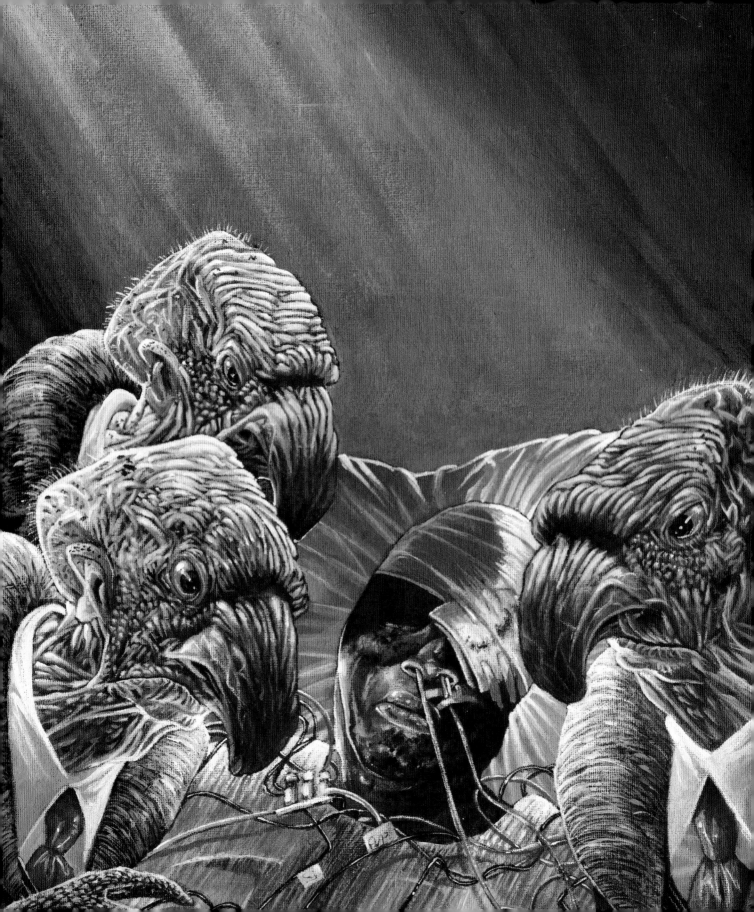

SO YOU WANT TO BE AN ILLUSTRATOR?

Understanding the Job

I SUSPECT THAT A LOT OF PEOPLE who say they want to be illustrators don't really know what an illustrator is. When I was a kid, I thought I wanted to be an artist, but I also knew that that wasn't quite it. At some point, maybe around the sixth grade, I stumbled upon the phrase *commercial artist*. That seemed to come a bit closer to what I was imagining, so I used it as my stock answer for the next several years, whenever anybody asked me what I wanted to be. Finally, in high school, my art teacher hipped me to the term *illustrator*. Yep, I was going to be an illustrator.

But what is an illustrator? An illustrator is an artist who uses images to communicate an idea to a larger audience. That's exactly what my image opposite does. Published in the *Houston Press*, it's about a man who was hurt in an explosion and then immediately set upon by lawyers—portrayed here as vultures. Even without knowing the exact story, the viewer should be able to tell by the elements in the piece that it's about an injured guy and, come on, vultures in suits around his bed? Lawyers!

Unlike a fine artist, an illustrator creates images, usually for a client, that serve a specific purpose. A fine artist may create work that is intended to be vague or completely open

LAWYERS, ACRYLIC ON CANVAS BOARD. PUBLISHED IN THE *HOUSTON PRESS*.

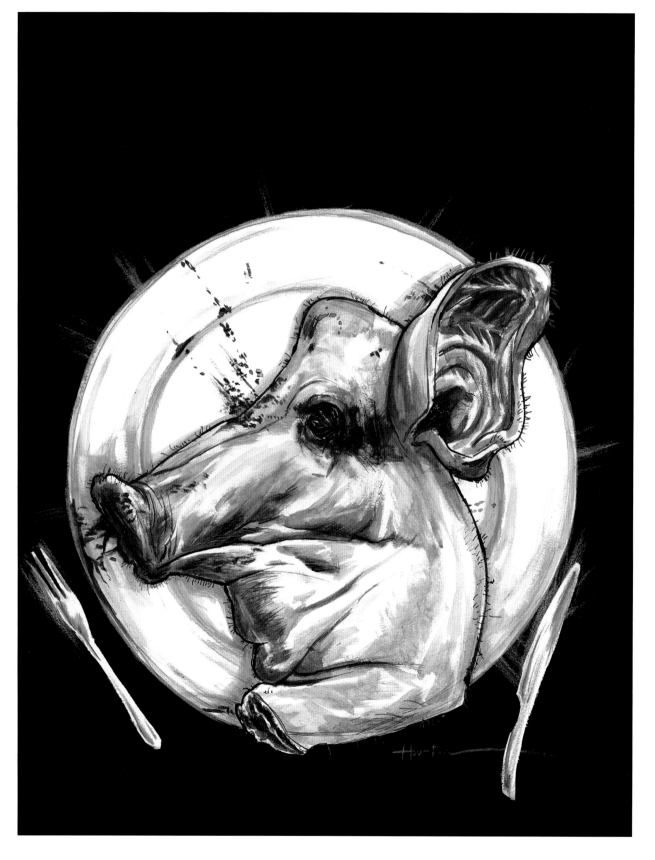

*EATING
HECTOR,*
ACRYLIC AND
INK ON PAPER.
PUBLISHED
IN *SEATTLE
WEEKLY.*

to interpretation, but an illustrator has to be concerned with conveying a specific message. Illustrators don't have the luxury of telling the audience that the work "means whatever you want it to mean" or of turning the tables and asking, "What do you think it means?" No, illustrators live and die by their ability to communicate an idea clearly. Succeed in that task and you've succeeded as an illustrator.

Here's what I mean. The piece OPPOSITE was for a story about a group that believes in getting to know their food *personally*. They went to some farm retreat, met a nice pig whom they named Hector, got to know him, and then butchered, cooked, and ate him. The illustration? Hector's head on a plate with knife and fork. Pretty much covers it.

Now, I don't want to suggest that fine art can't be, or isn't, about telling a story or communicating a concept to the viewer. It absolutely can accomplish those feats. But it can also be self-referential or obscure in a way illustration cannot. While an illustrator should make every attempt at making quality art that he or she can be proud of, the ultimate goal is to

TRACY JACOBS, *MAP*, ACRYLIC ON PAPER. COURTESY OF THE ARTIST.

please the client and create work that will be understood by a majority of viewers.

The difference between what fine artists do and what illustrators do is summed up by the piece ABOVE, by Tracy Jacobs. It's gorgeous! I could spend all day drinking up those inky blacks and beautiful textures. But it's a work of fine art. It's not telling me a story—nor was it intended to.

I *do* want be an illustrator. Tell me I'm not out of my mind!

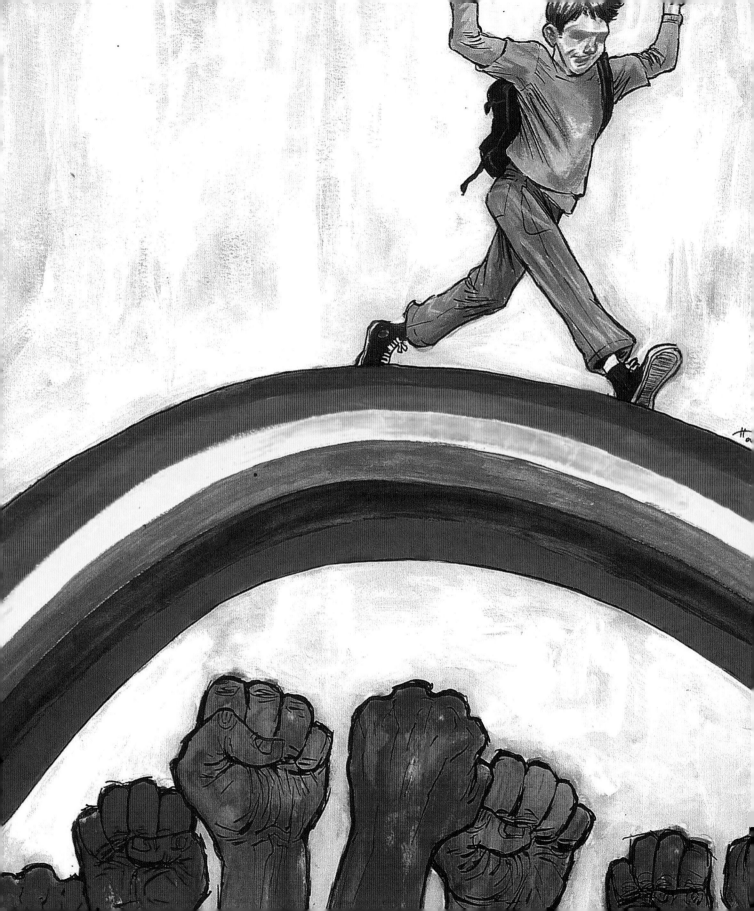

WHAT ARE ILLUSTRATIONS?
Making Pictures Speak

WE'VE TALKED A LITTLE BIT ABOUT BEING AN ILLUSTRATOR. Now let's discuss illustrations themselves. What is an illustration? Simply put, an illustration is an image that conveys a concept or helps convey a concept.

Take a look at the piece opposite, which I did for a cover story in the *Philadelphia Weekly*. The story was about a young high school boy who embraced being gay and, by doing so, rose above the bullies in his school. The rainbow bridge signals that the story is about gay pride. Using the bridge to safely transport the boy on his journey—literally from one side of the image to the other—sets up a solid, legible concept. Coloring the boy naturally while using an unnatural, angry red for the bullies' fists emphasizes the boy's humanity while dehumanizing his enemies.

Very often an illustration will accompany an article. Obviously, reading the article will inform the viewer about the topic being illustrated. But when an illustration is used along with an article, the illustration can serve three purposes:

1. To better communicate the information by reinforcing the article's concept
2. To summarize the information
3. To catch the eye of the reader and drive them to the article

OUT, ACRYLIC AND INK ON PAPER. PUBLISHED IN THE *PHILADELPHIA WEEKLY.*

GENRES OF ILLUSTRATION

There are several genres of illustration: editorial, advertising, fashion, and technical illustration, as well as comics and graphic novels. The vast majority of the work that I do is editorial—illustrations that accompany stories. Editorial illustrations very often have a particular point of view, but not always. They're usually associated with newspapers and magazines, but I would also include books, CD covers, and posters in this category, because generally these are also concept driven. Editorial illustration is an incredibly broad category and provides endless opportunities to get creative.

The illustration RIGHT was for a magazine article about how the anonymity of the computer allows for all sorts of private things to be said in public with no fear of recrimination. I utilized the image of the confessional. The tilting beam in the center shows the beginnings of the breakdown between the public and private—the guy on the right is starting to edge into the left-hand space. This is a very specific concept with a fairly straightforward visual.

OPPOSITE LEFT is a beautiful piece by master caricaturist Steve Brodner. This is a pretty simple illustration about the Bush family that uses imagery from the popular *Game of Thrones* TV show to get the reader to

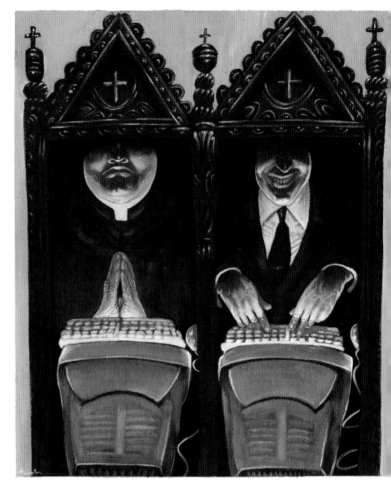

COMPUTER CONFESSIONAL, ACRYLIC ON CANVAS BOARD. PUBLISHED IN *URBANITE*.

understand the concept. This one had a banner and headlines slapped on it—but even without the text, the image tells you everything. The elements Brodner included—the costumes, the placement of the Bushes from oldest (former president George H. W. Bush) in the back to the youngest (Jeb Bush) in the front—really get to the point. By creating a sort of geographical hierarchy in the piece from back to front, he's essentially created a visual lineage from the throne itself and the first Bush

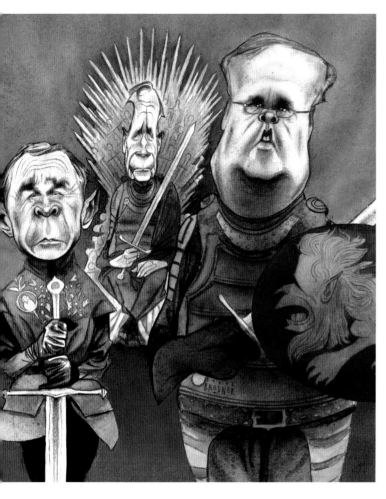

STEVE BRODNER, *GAME OF THRONES*, GRAPHITE AND WATERCOLOR, DIGITAL. PUBLISHED IN *NEWSWEEK*.

DEANNA STAFFO, ILLUSTRATION FOR FLANNERY O'CONNOR, *A CIRCLE IN THE FIRE AND OTHER STORIES* (LONDON: THE FOLIO SOCIETY, 2013), ACRYLIC PAINT AND GRAPHITE.

who occupied it to the latest designated successor. Also note the excellent likenesses.

As I said, I include book illustrations in the editorial illustrations category. The lovely piece ABOVE RIGHT, by Deanna Staffo, is an image for a collection of Flannery O'Connor stories. As an illustrator, you have an obligation to communicate the story or concept to the audience. When the piece is accompanied by text, however, the illustration need not explain every detail of the larger story. Look at this image and consider the characters—their expressions, clothing, body language, props. What do these things tell you about them? How about the sparse environment? What about the colors? Do I know the exact story from looking at this? No. But because of the elements Staffo includes, and the way they're depicted, I get the gist.

As I mentioned, there's also illustration created for advertising, which is very specific to the products being

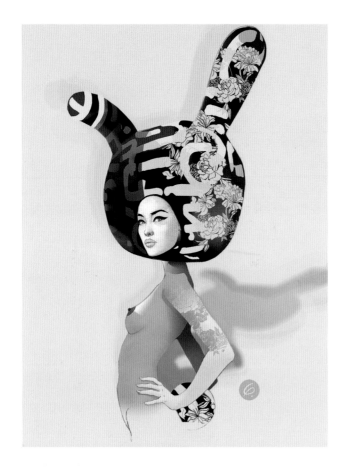

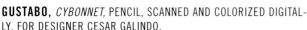

GUSTABO, *CYBONNET,* PENCIL, SCANNED AND COLORIZED DIGITALLY. FOR DESIGNER CESAR GALINDO.

JENNIFER MCCORMICK, CMI, ARTFORLAW.COM, *SKULL FRACTURE,* DIGITAL. RENDERED BY THE ARTIST.

advertised, as well as fashion illustration, like the piece ABOVE. What is this stunning illustration about? The bonnet! The bonnet is the show.

And there are technical illustrations, which typically appear in guides and manuals, and medical illustration, which is an incredibly specialized art form. (Hint: You need a graduate degree from a medical school to become a medical illustrator.) ABOVE RIGHT is a wonderful medical illustration by Jennifer McCormick—a multitalented visual artist. This is what a skull fracture looks like. Is it an illustration? Absolutely! It is editorial? No, because while

it communicates a message (skull fracture), there's no story or concept—just an image showing a serious injury.

Although comics and graphic novels are genres of illustration, they're also fields unto themselves. In this category, I'd also include character design for animation and gaming, because being a good illustrator helps when designing characters, and being able to conjure interesting or believable characters is helpful when creating an illustration. I could include even more specialized kinds of illustration, but I think I've listed the most common forms.

GREG'S RULES FOR ILLUSTRATORS

Rule #1: Don't Be Stupid!

I'm always telling my illustration students not to be stupid, and frankly I think it's pretty good advice for anybody. When you're an illustrator, you're competing for jobs with tons of other talented illustrators. So set yourself up for success. The only way—outside of nepotism, sheer luck, or magic—that you can succeed is to work hard and create opportunities for yourself. If you've made an appointment with an art director or other client, arrive on time. Don't get drunk beforehand. Don't wear a T-shirt that says "Kiss My Grits." Don't be disagreeable. Don't act like you have the job before you actually do. Don't tell the art director that you never read her magazine. Don't tell the client how much you hate his product. Don't make a pass at the client. Don't price yourself out of the job. This may all seem pretty obvious—in fact, I hope it does. But you'd be surprised how stupid people can be. Put yourself in

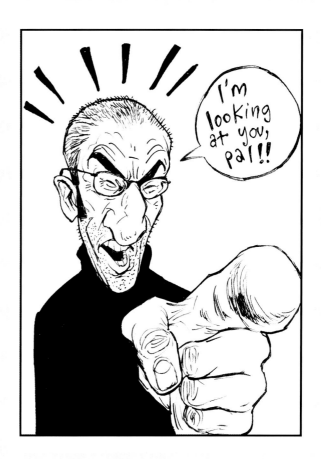

the best position to get a job, and then follow through. Give yourself the best chance to do a good job. A client you work for once is a client you may work for many more times. It's up to you to be professional.

NARRATIVE VERSUS CONCEPTUAL ILLUSTRATION

An illustration can be narrative or conceptual. Think about a book cover versus an interior illustration. The cover illustration can be narrative, visually fleshing out a moment in the book, or it can be conceptual—an image that somehow captures the quality of the book but is not specific to any passage.

Let's take Bram Stoker's *Dracula,* for example. A cover for the novel might depict a scene from the story, but it could also show a bat wing or a misty void barely concealing a scary figure. These images are not from a specific moment in the story; rather, they convey the "feel" of the story. In my piece RIGHT, Dracula dominates the image. This is a more conceptual take on the story. I use his cloak as a device—it comes alive like snakes or tentacles and swirls about him at his command. The idea is that the undead Dracula *lives*. Because the character and story are so familiar, just this image is enough to convey the general idea to the viewer.

Alex Innocenti's cover, OPPOSITE, takes a different approach. Innocenti has chosen to go with a more narrative image, depicting a scene from the book. While he includes some whimsical interpretations, he's essentially faithful to a passage in the story. Unlike my

DRACULA, ACRYLIC ON CANVAS BOARD. PROMOTIONAL PIECE.

illustration, which shows a monstrous vampire, Innocenti taps into the romantic elements in the book by making Dracula handsome.

Interior illustrations for a book tend to be narrative rather than conceptual, typically depicting scenes from the story. If, for example, an art director decides that the illustrator should work on an episode from Mary Shelley's *Frankenstein* in which the monster confronts Dr. Frankenstein, the illustration will show that action, in that setting, featuring those characters as described in the book.

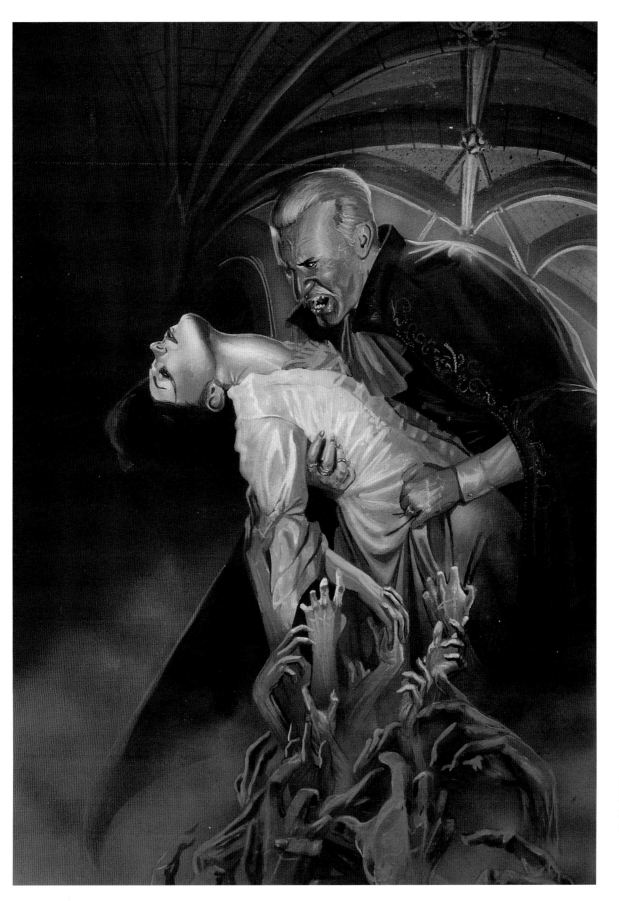

ALEX INNOCENTI,
DRACULA, ACRYLIC
AND AIRBRUSH.
PROMOTIONAL PIECE.

STAND-ALONE VERSUS SEQUENTIAL ILLUSTRATIONS

Illustrations can also be individual, stand-alone images or a series of sequential images. Illustrated books contain multiple interior pictures, of course, but even magazines and newspapers will sometimes have a cover illustration for a story as well as interior illustrations for the same story.

RIGHT is a cover I did for the *Washington City Paper*. The story was about a quasi-governmental agency—the Department of Consumer and Regulatory Affairs (DCRA)—that acts as a liaison between landlords and renters. According to the article, the agency was in the pocket of the landlords, and so I designed the image like a Russian propaganda poster, depicting the agency as a goon backed by Thomas Nast–esque fat cats. I threw in some buildings for informational reasons (the story is about rental properties) and showed the renter about to be crushed under the thumb of the agency—conceptual, but fairly simple.

Two of the interior images for the story are shown OPPOSITE TOP. In the one ON THE LEFT, the agency is giving unequal treatment to the fat cat and tenant—represented by the thumbs-up/thumbs-down action. In the second illustration, ON THE RIGHT, the carpetbagging fat cat

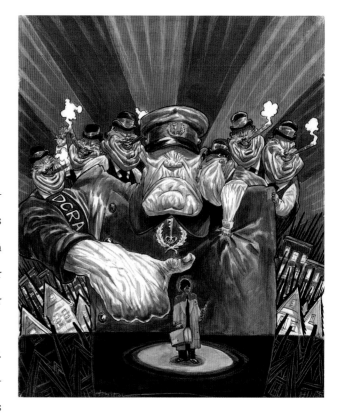

DCRA, ACRYLIC, COLORED PENCIL AND INK ON PAPER. PUBLISHED IN THE *WASHINGTON CITY PAPER*.

gets preferential treatment again, as the tenant gets the literal boot. The illustrations are conceptual, but note how the themes, styles, characters, and tone remain consistent.

Of course, the classic example of sequential illustration is the comic, whether it's a short strip like George Thomas Meggitt's *Billy Bowwow,* OPPOSITE BOTTOM, a full-length comic book showcasing the adventures of Batman, or something even longer, like Chris Ware's graphic novel *Jimmy Corrigan, The Smartest Kid on Earth.* Because comics are an art form in themselves, however, I won't be focusing on them in this book.

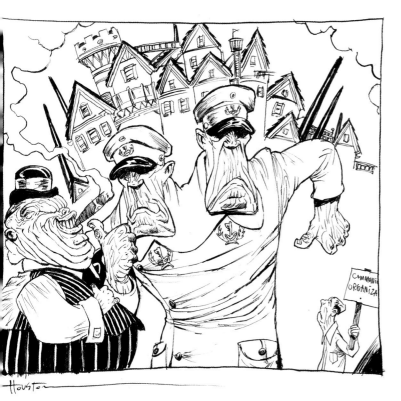

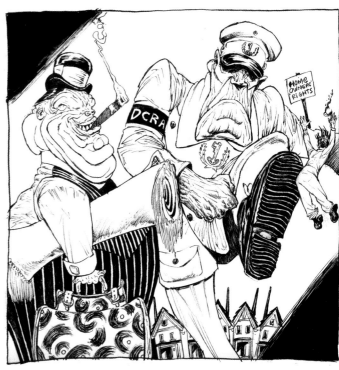

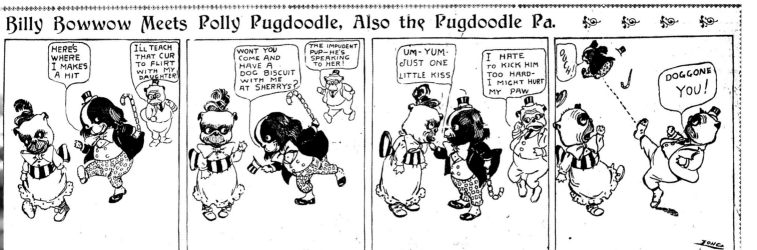

TOP: INTERIOR ILLUSTRATIONS FOR DCRA STORY, INK ON PAPER. PUBLISHED IN THE *WASHINGTON CITY PAPER*.

BOTTOM: GEORGE THOMAS MEGGITT, *BILLY BOWWOW* COMIC STRIP, C. 1920. AMALGAMATED PRESS.

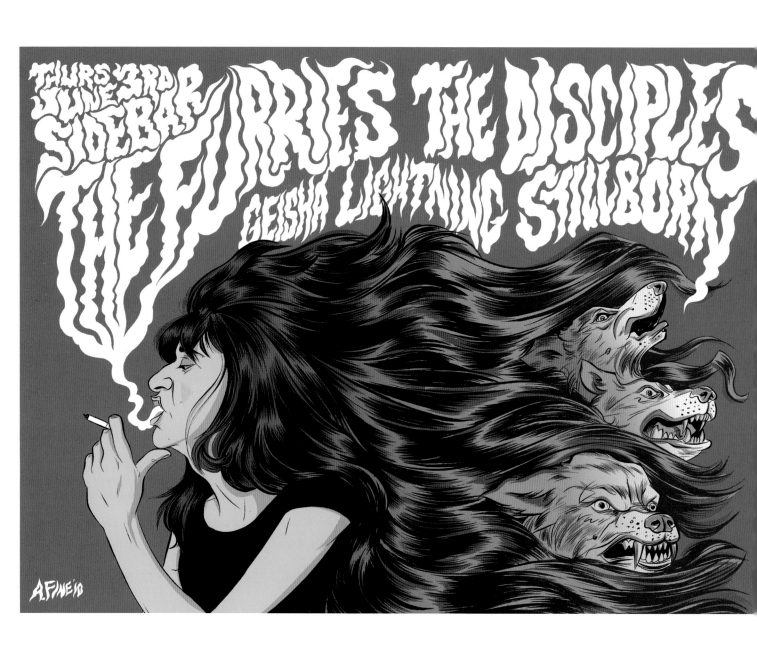

ILLUSTRATIONS—UTILITARIAN *AND* DECORATIVE

So, an illustration is an image that communicates a concept or story. It can exist alone or in conjunction with a text, title, or headline. Unlike a work of fine art, an illustration doesn't exist purely to exist—to take up space or decorate a rumpus room. Illustrations are, at their core, utilitarian. But now I will contradict myself. While everything I've said up to this point is true, illustrations are also decorative to some degree. For example, an illustration for a CD cover may give you an idea of the CD's contents while also grabbing your eye. An illustration for a festival poster helps convey the concept or feel of the event while being colorful, interesting, or provocative enough to get people's attention as they pass it on the street. It must be both informative *and* decorative.

The Alex Fine poster OPPOSITE was for a show at a Baltimore bar called Sidebar. Note Fine's beautiful incorporation of hand lettering. He does a great job of capturing the attitude of the show while not focusing on one band. It's an arresting image that grabs the eye. Wouldn't you stop to look at this if you saw it while walking down the street?

And then there are books. In a bookstore, a book may sit on a shelf amid hundreds of other books. The cover not only has to convey some information about the story to a potential reader, but it first has to draw that viewer's eye away from the other books competing for attention. Illustrations rarely exist outside of a commercial realm. They adorn products. Whether on book jackets, CD covers, video-game boxes, movie posters, newspapers, cereal boxes, T-shirts, comic books, DVD boxes, magazines, or websites, illustrations are used to sell things or to dress up things that are meant to be sold. Even when illustrations exist to make readers look at an article, their purpose is to control the eye and draw it to an intended target. Concepts matter and a dash of style helps, too. To a large degree, the name of the game is visual manipulation.

ALEX FINE, SIDEBAR CONCERT POSTER, INK ON PAPER, DIGITAL. COURTESY OF THE ARTIST.

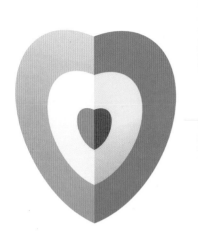

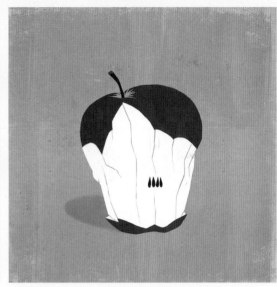

ILLUSTRATION AND GRAPHIC DESIGN— WHAT'S THE DIFFERENCE?

Some folks confuse graphic design and illustration. After all, illustration is graphic by definition, and both illustration and graphic design are about communication. So what's the difference? Graphic design serves many of the same purposes as illustration, but the kinds of stories told via illustration tend to be different than the ones told via graphic design. I'm not a graphic designer and don't want to define that art form through my lens. I'll just say that illustration is a potentially "verbose" form of communicating while graphic design is far more succinct.

While an illustration can be filled with detail and still succeed, graphic design is about getting straight to the point in the cleanest, least jumbled way possible. Think about how William Golden's iconic eye logo for CBS gets right to the point. Or consider the smart, elegant logo ABOVE LEFT, by graphic designer David Gillis, for Catalog Design Studios, whose slogan is

"We love catalogs." The logo communicates the brand with no visual muss or fuss. Now, Compare Gillis's logo with the piece ABOVE CENTER, which I did for a story on Paul Verhoeven's film *Hollow Man.* Talk about visually verbose!

Both forms of visual communication are valuable, and in fact, there can be some overlap between them. There are lots of great illustrators whose work is very graphic. For example, look at the piece ABOVE RIGHT by Emiliano Ponzi. It's economical, smart, and super graphic. See what I mean?

ABOVE, LEFT TO RIGHT:

DAVID GILLIS, LOGO CONCEPT FOR CATALOG DESIGN STUDIOS.

HOLLOW MAN, INK, WHITE INK, AND ACRYLIC ON PAPER. PUBLISHED IN THE *WASHINGTON CITY PAPER.*

EMILIANO PONZI, *APPLE EVIL CORE,* DIGITAL. COURTESY OF THE ARTIST.

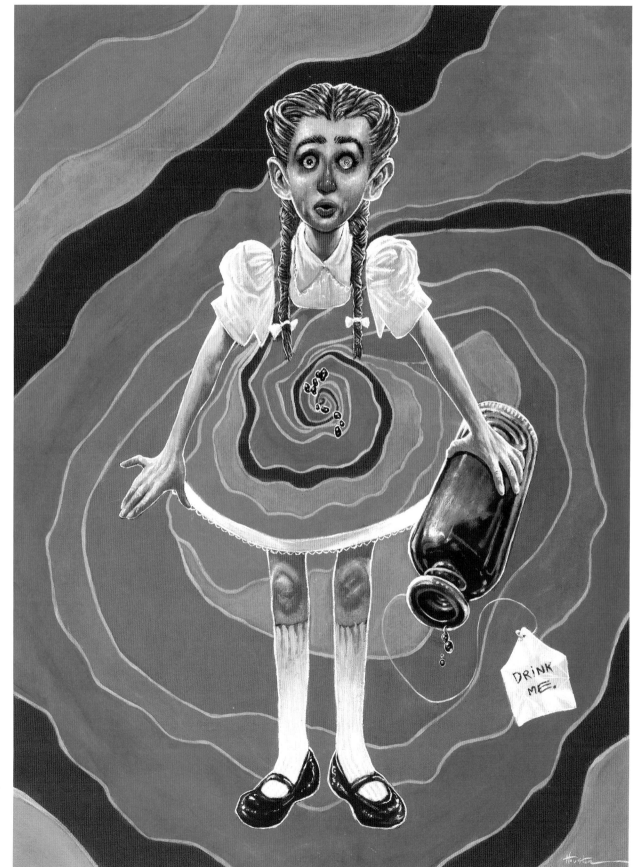

DRINK ME,
ACRYLIC ON
CANVAS BOARD.
PROMOTIONAL
PIECE.

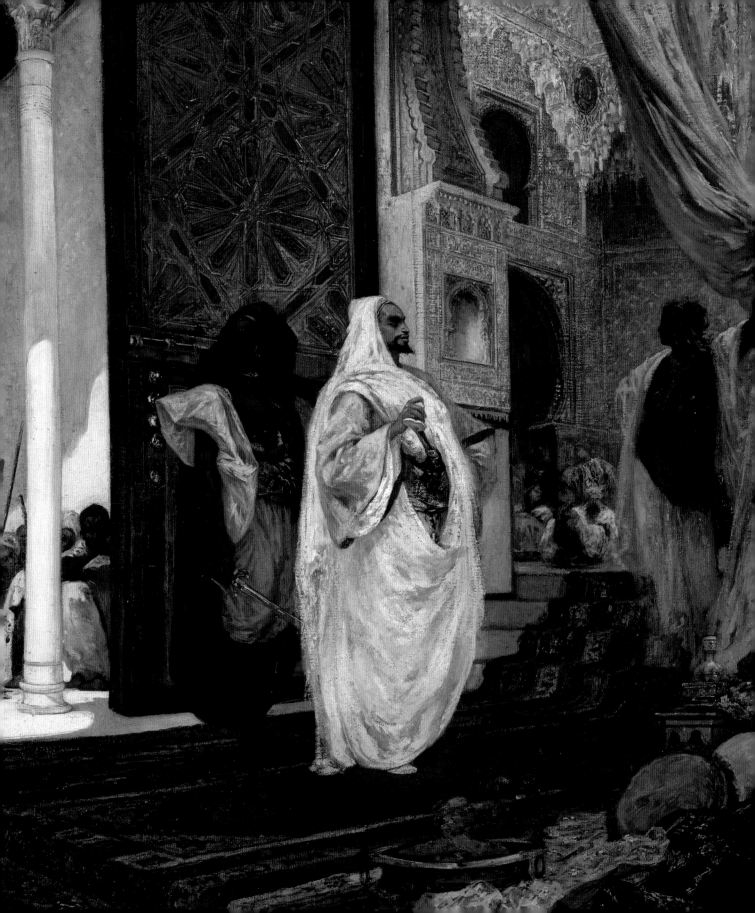

ART AND ILLUSTRATION

Surveying Illustration's History

A GOOD ART SCHOOL PROGRAM starts with a solid foundation year. This is when all students take required fine arts classes, are ground down to their socks, and then are built back up again. Essentially, it's an opportunity to leave behind everything they think you already know (but don't).

But during that foundation year, some professor will inevitably tell you that pursuing a career in illustration is tantamount to standing on a street corner in a tube top, trawling for johns. It's a tradition as old as the oldest profession itself: You declare a major in illustration and are immediately labeled a sellout. A whore.

I like a good tradition as much as the next guy. And I don't mind a little name calling now and then. What bothers me about this is that it's got it backward. I mean, take a look at the painting opposite. Painted in 1870, it's called *Entering the Harem,* and it's by Georges Jules Victor Clairin. It's in the collection of the Walters Art Museum in Baltimore. It's art, right? Yes, but it's also *illustration.* It's not the illustrators who bastardized art, it's the so-called "fine" artists.

GEORGES JULES VICTOR CLAIRIN, *ENTERING THE HAREM,* C. 1870, OIL ON CANVAS. COURTESY OF THE WALTERS ART MUSEUM.

ART AS ILLUSTRATION

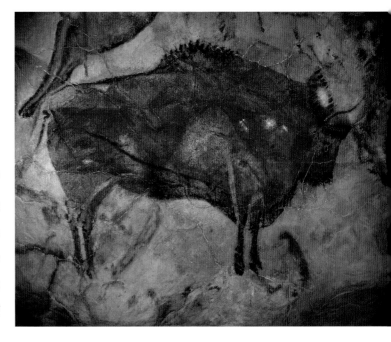

What's among the oldest forms of visual art known? Cave paintings. Do you think some caveman was sitting around, trying to get in touch with his feelings when he painted the picture AT RIGHT? Cavemen didn't think like that. Cave paintings are reportage: Og sees Rog get trampled by a bison. Og paints it on the wall. The rest of his clan see it. Now they know what happened to Rog.

Want another example? What about ancient Egyptian art? Wall paintings in Egyptian tombs are nothing more than the illustrated story of the dead guy's life. It's like an obituary. Take a gander at the relief OPPOSITE TOP. I have no idea what's happening here, but I do know that it is *not* the artist's rumination on the meaning of life. It's actually a diary entry—a story being told for later generations.

Or take Greek vase paintings. Did they depict the artist's inability to come to terms with a lack of anything original to say? No! This image on the vase OPPOSITE BOTTOM LEFT is thought to represent the *mousikoi agones*—a musical competition held during some festival. The character in the center is playing a kithara and the gents on either side are thought to be spectators or judges. So it's an illustration of a music festival. If it were done today, it'd be a poster or maybe a magazine illustration.

WALL PAINTING OF A BISON, C. 14,500–12,000 BC, ALTAMIRA CAVE, SPAIN.

OPPOSITE BOTTOM RIGHT is a Roman mosaic depicting centaurs pulling Dionysus and Ariadne in a wagon. Like the Greeks, the Romans really loved their gods and took every opportunity to illustrate them going about their godly business. So we've moved from straight reportage to storytelling. But it's still illustration.

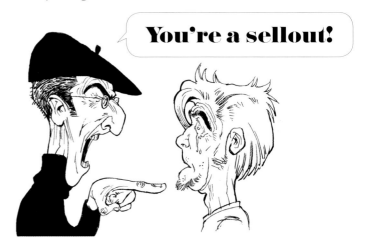

You're a sellout!

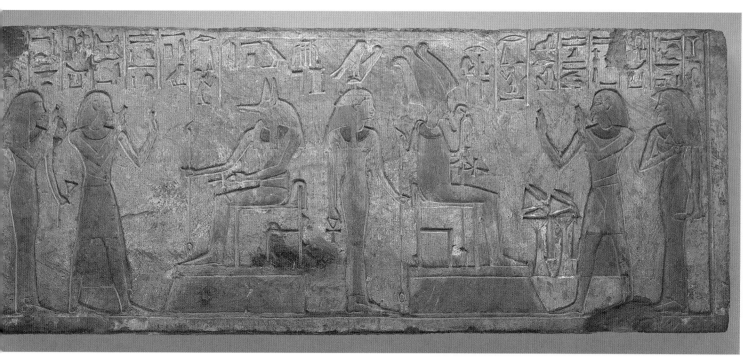

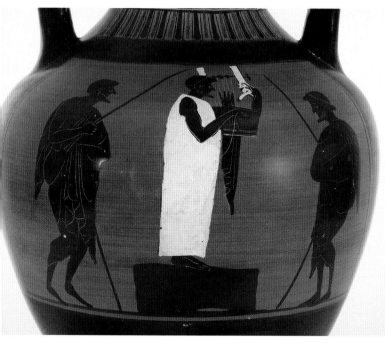

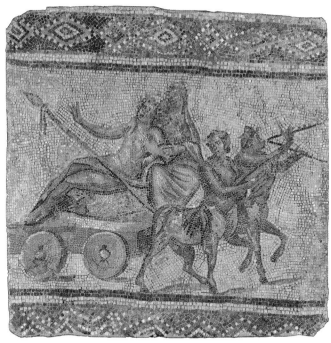

TOP: RELIEF OF DJESER-KA, 1450–1400 BC, SANDSTONE WITH BLUE POLYCHROME. COURTESY OF YALE UNIVERSITY ART GALLERY.

ABOVE LEFT: BLACK-FIGURE PSEUDO-PANATHENAIC AMPHORA, C. 500–485 BC. COURTESY OF THE WALTERS MUSEUM OF ART.

ABOVE RIGHT: MOSAIC FRAGMENT WITH A DIONYSIAC PROCESSION, LATE 2ND CENTURY–EARLY 3RD CENTURY AD. COURTESY OF YALE UNIVERSITY ART GALLERY.

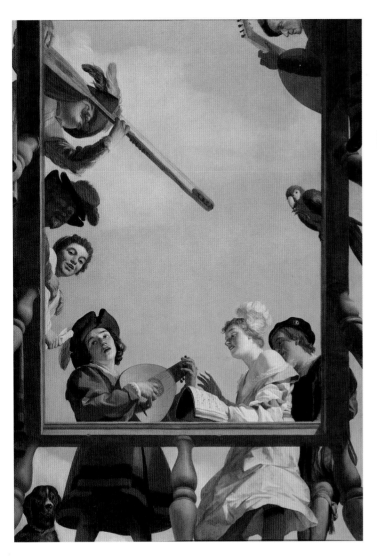

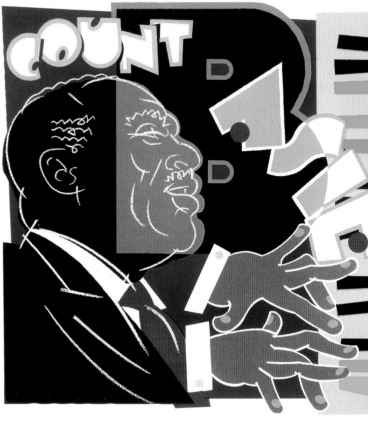

GERRIT VAN HONTHORST, *MUSICAL GROUP ON A BALCONY,* 1622, OIL ON PANEL. DIGITAL IMAGE COURTESY OF THE GETTY'S OPEN CONTENT PROGRAM.

PAUL ROGERS, *COUNT BASIE,* ACRYLIC AND INK. FROM WYNTON MARSALIS, *JAZZ ABZ: AN A TO Z COLLECTION OF JAZZ PORTRAITS* (SOMERVILLE, MASS: CANDLEWICK PRESS. 2005).

As is the seventeenth-century Dutch painting ABOVE LEFT. In fact, you can follow a tradition of illustrating musical events and music all the way from ancient Greece up through great contemporary illustrators like Paul Rogers, whose image of jazz icon Count Basie is shown ABOVE RIGHT, without missing a beat. Obviously these images look different. But apart from an evolution in style and the use of different mediums, is the concept so different? These artists are telling stories about music. The pieces are playing to an audience, communicating in a way that viewers will understand.

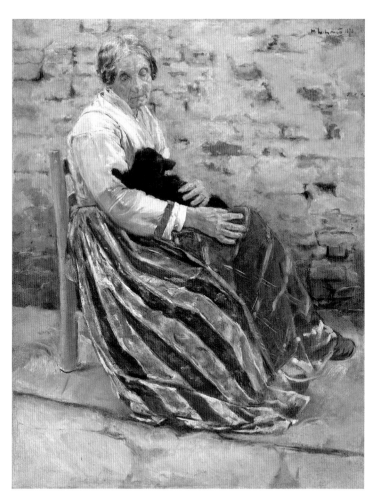 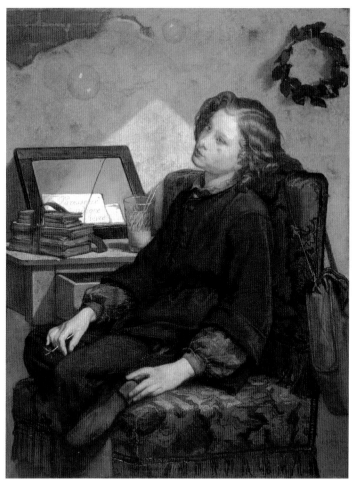

PORTRAITS AND CARICATURES AS ILLUSTRATION

When you think about it, even portraits are illustrations. Look, for example, at the portrait ABOVE LEFT. Who is this woman? What do her clothes, expression, body language, and location tell us about her? And what's with the cat? The choices Max Liebermann made in painting this person inform the viewer about who she is. He is therefore using visual elements to tell a story about this person. Smells like illustration to me.

And what about the kid in the picture ABOVE RIGHT? Thomas Couture paints him as a daydreamer, preoccupied with his thoughts rather than his schoolwork. How do I know? Well, there's his expression and body

MAX LIEBERMANN, *AN OLD WOMAN WITH CAT,* 1878, OIL ON CANVAS. DIGITAL IMAGE COURTESY OF THE GETTY'S OPEN CONTENT PROGRAM.

THOMAS COUTURE, *DAYDREAMS,* 1879, OIL ON CANVAS. COURTESY OF THE WALTERS ART MUSEUM.

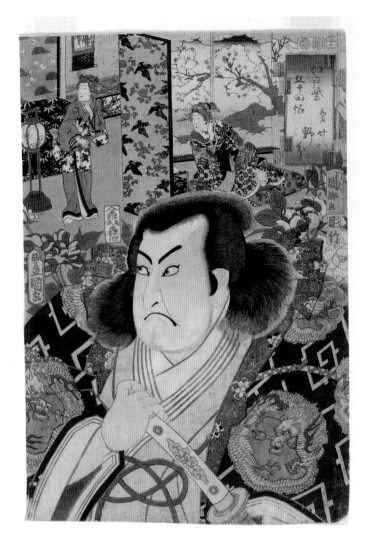

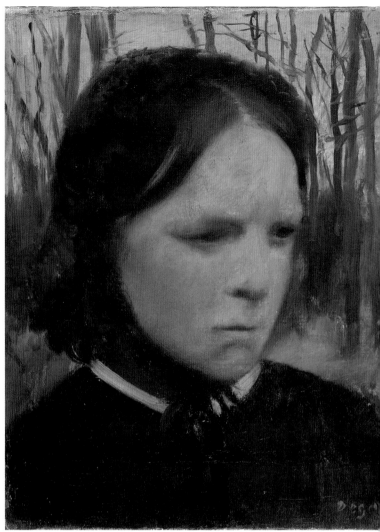

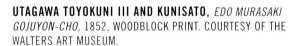

UTAGAWA TOYOKUNI III AND KUNISATO, *EDO MURASAKI GOJUYON-CHO*, 1852, WOODBLOCK PRINT. COURTESY OF THE WALTERS ART MUSEUM.

EDGAR DEGAS, *PORTRAIT OF ESTELLE BALFOUR*, 1863–1865, OIL ON CANVAS. COURTESY OF THE WALTERS MUSEUM OF ART.

language, but Couture includes props like the unopened schoolbooks, the desk, and the bubbles floating in the air, and all this information tells the story. Imagine it updated to 1943, or 1984, or now. No matter the era, a painting like this could be an illustration for a story about the kid who'd rather daydream than do his homework.

ABOVE LEFT is a beautiful example of Japanese portraiture. This print of a kabuki actor was started by Toyokuni and finished by his student Kunisato, who filled in the background. Here, the main character is visiting his lover, who's afraid of a typhoon and hiding behind the screen. Lots of story happening. My fine art professors would dismissively have said, "Too illustrative"!

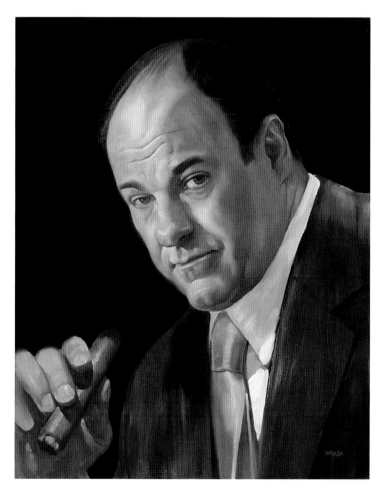

ROBERTO PARADA. *TONY SOPRANO,* OIL ON LINEN. PUBLISHED IN *NEW YORK* MAGAZINE.

The haunting Degas painting OPPOSITE RIGHT depicts the artist's cousin, who at the time this was painted was both mourning the loss of her husband *and* going blind. Degas eventually went blind, too, and this piece explores the experience of seeing people who can't see. Consider the visual elements he includes: the dark clothes, the bare forest, the eyes cast downward, the openness of her face. He's telling her story. This is an illustration.

Now look at the beautiful piece AT LEFT, by Roberto Parada—a portrait of a TV character (played by actor James Gandolfini) painted in a classical style. Using a minimalist background, the artist forces the viewer to experience the story told by the face, expression, clothes, and the prop the subject holds. Like the Degas image, it's just a head, shoulders, and a background. And, as with the Degas painting, you can tell a lot from just these few elements. Both portraits communicate a story about the subjects. One hangs in a museum, and the other was printed in a magazine, but both are illustrations.

I've talked a little about portraits, so let's touch on caricatures. (We'll return to both subjects at greater length in chapters 11 and 12.) When I say "caricature," the first image that comes to mind may be of a guy drawing your kid at a booth on the boardwalk. Or possibly you're a little more cultured, and you think of the stylish work of the late Al Hirschfeld or conjure images by contemporary masters like Steve Brodner or Philip Burke.

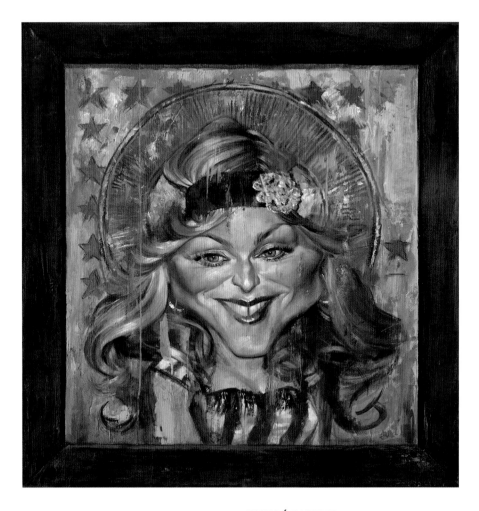

WOUTER TULP, MADONNA, ACRYLIC. COURTESY OF THE ARTIST.

HONORÉ DAUMIER, *COMTE D'ARGOUT,* FROM THE SERIES *CELEB-RITIES DE LA CARICATURE,* 1832, LITHOGRAPH. COURTESY OF THE YALE UNIVERSITY ART GALLERY.

ABOVE is a terrific caricature of Madonna by Wouter Tulp. He uses exaggeration and a halo along with some stylistic choices to communicate an impression of this person to the viewer.

And OPPOSITE is a piece by Honoré Daumier, who was zinging folks with witty drawings way back in the 1800s. I have no idea who this particular guy is, but I know two things: He had a large nose, and Daumier wanted you to notice that he had a large nose. Daumier liked to deflate the pompous and level the elite—lawyers, judges, high society—and his weapon of choice was the caricature. It's a proud tradition going back at least as far as Leonardo da Vinci.

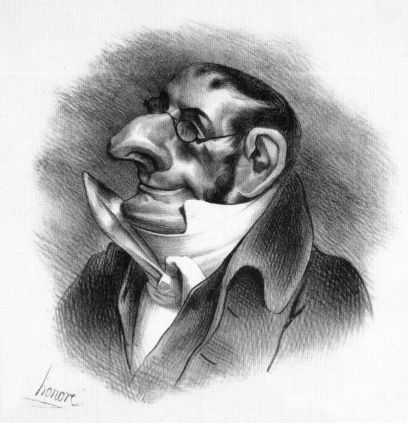

honore

D'ARG....

GET SOME EXERCISE!

ILLUSTRATE AN OP-ED PIECE

You haven't had the chance to get your hands dirty yet, and I'll bet you're just itching to get started. So take a break from all the reading and get illustrating.

As I've stressed, there's a big difference between creating an image for yourself and creating one for a specific purpose. When I work with young illustrators, the first thing I do is try to get them to understand illustration at its most basic level. And there's nothing more basic than the mighty op-ed illustration.

For those of you too young to remember actual newspapers, op-eds are columns and essays that appear on the page opposite the editorial page. They are opinion pieces and can range from thoughtful takes on big issues like war, racism, or poverty to rants about trash pickup. The point is that they are decidedly one-sided. Very often, an op-ed is accompanied by an illustration to help the reader get the gist of the piece. Since illustration in its purest form is an image created to communicate a story or concept, and since an op-ed is usually a very straightforward piece with a clear point of view, illustrating an op-ed is a great way to marry the written word with an image in a clean, clear way.

Want to give it a shot? You'll need something to illustrate with and something to illustrate on, so get a pencil and a sheet of paper. I want you to time this exercise, so you'll also need a clock or timer.

First, draw a simple box on the paper—any size. Now you just need a topic and a point of view. In the real world, an art director would ask you to create an illustration for an op-ed that's already been written, so you wouldn't be choosing a side of the argument. It would be assigned to you, and the illustration you'd create would be required to echo that point of view. But for this exercise, I'll pick the topic and you'll pick the point of view.

What's a juicy topic? How about freedom *from* religion? You know how some folks get upset about prayers in schools or incorporating the word *God* in the Pledge of Allegiance? Let's pretend that an art director has contacted you to create an illustration to accompany an op-ed about freedom from religion. Choose a position on the topic, pro or con, and pretend it's the one that was assigned. Give yourself fifteen minutes on the clock and rough out an illustration that visually conveys the position you've chosen. Just two caveats: This is not an editorial cartoon, so don't rely on words or symbols to tell the story. (You're an illustrator, not a writer.) And don't get bogged down in making it "look good." Style isn't the issue for this exercise. Clarity is. OK...go!

Finished already? How'd you do? My guess is that this was harder in practice than in theory. If possible, show your drawing to some folks without telling them what the topic is and see if they can figure out what you were trying to say. If they don't get it, tell them the topic but not the position you took. Can they tell whether your piece is pro or con?

I've given this op-ed assignment more times than I can remember, and almost every person I've given it to finds it very difficult. So if you fumbled a bit, don't be discouraged. Why would I start you off with such a difficult task? Because even in its most basic form, telling a story through illustration is a real challenge.

When assigning you this job, I gave you a ridiculously short time frame because I wanted you to go with your gut and not overthink the concept. Sometimes illustrators get so bogged down in coming up with an image that they end up missing the deadline or they turn in something that isn't very good. I also didn't want you to get too wrapped up in thinking about a style. I just wanted you to work in the quickest, simplest way possible so that, stripped of all the possibilities that more time would allow, you'd end up with a piece that tells the story boldly and concisely. Even if you failed in the attempt, the knowledge gleaned from the experience will serve you well, thus underscoring the most important tenet of my philosophy: Embrace failure! Everybody fails, and you'll always learn from an honest attempt.

Now that you have an idea of what this is about, are you ready to try another one? Get the paper, draw the box, and this time set your clock for ten minutes—let's up the ante! Not only do you have less time, but I'm assigning the topic. The op-ed you'll be illustrating is an article *supporting* censorship. That is, it's a *pro-censorship* piece. It doesn't matter whether you believe in the benefits of censorship or not. As a professional your job is to make this the best illustration possible. (And you thought the last one was tough.)

And . . . go!

Finished already? I assume that, due to the parameters, this one was more challenging. But was it harder? I'll bet that, having done one before, you actually found this one a little bit easier in some ways. That's how illustration is: Each job presents its own challenges, but the more jobs you do, the more comfortable you become meeting those challenges. Creating a visual vocabulary, learning how you work best, and discovering your strengths and limitations allow you to tackle jobs with a confidence and clear-mindedness that will serve you well as a professional. And it all starts with exercises like these. Now that you've done these two op-ed assignments, do some more. Go through your local paper or check out some online news sources for material. Give yourself different requirements. Change the sizes and shapes. Give yourself more time. See what happens. You can only grow from the experience.

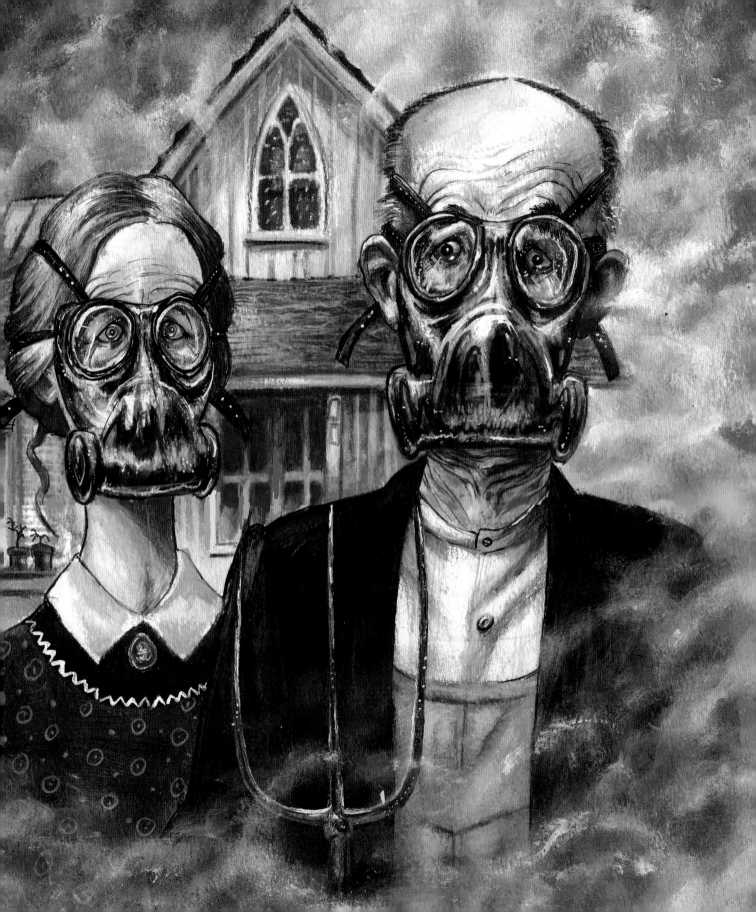

YOUR TASTE
DOESN'T MATTER

Making Art for Clients

AS I'VE SAID, BEING AN ILLUSTRATOR means making art for a client, not for yourself. Although this sounds like a pretty simple concept to grasp, the truth is that many artists can't shake the impulse to create work for themselves. You really have to put your ego in neutral. When my students engage in class critiques, I warn them not to use the phrases "I like" or "I don't like." Nobody cares what you like. It's all about what the *client* wants.

The piece opposite was for an article in the *Miami New Times* about homes being threatened by toxins in the ground. It wouldn't have been my first choice to go with a play on Grant Wood's famous painting *American Gothic*. It's been done so many times. But the client liked the concept, so I went with it, and in the end I think it's provocative and gets the point across. Could I have come up with a better visual metaphor? Maybe. But it wasn't my call.

Of course, as with anything you create, you want your work to be the best it can be and to reflect your talent and, to the extent it's possible, your vision. But that doesn't give an illustrator the right to impose his or her taste on the client. You have an obligation

NOXIOUS PROPERTY, ACRYLIC AND INK ON PAPER. PUBLISHED IN THE *MIAMI NEW TIMES.*

to give the client the benefit of your experience when discussing a job. But, once you agree to take on that job, your assignment is to make the best work you can *for the client*. Trying to railroad the client into seeing things your way isn't very professional, and giving the client a finished piece that's different from what you both agreed to is entirely unacceptable.

So how do you make a great illustration when you don't like the concept? You suck it up and work that much harder! Make professional-quality work. You don't have to be in love with it. The critics might hate it, but don't let them fault the craftsmanship. Always make work you can stand behind, even when it doesn't tickle your fancy.

Also, be open minded. Sure, there are a lot of people out there who are bad at their jobs—including art directors. But just because you don't see eye to eye doesn't mean the client doesn't have a point. Illustration at the professional level is collaborative, and if you give your client a chance, you may come to realize that, between the two of you, a great piece is just waiting to be made.

I'm a man of taste, but who cares?

DEAD BABY WITH MOTHER, INK ON PAPER. FOR THE WASHINGTON CITY PAPER (NOT PUBLISHED).

I'm going to show you some examples of illustrations that I did in which the client's vision trumped my own. Some worked out great. Some didn't. But my obligation to be professional never wavered.

The illustration ABOVE was for a cover story about a young Washington, D.C., couple who took their infant home from the hospital only to let him starve to

GREG'S RULES FOR ILLUSTRATORS

Rule #2: Listen, Ask, Repeat!

Illustrators need to be on their toes. You may find yourself handling a wide variety of jobs for a wide variety of clients. And you may have little or no knowledge of the subject matter you're asked to illustrate. In my career, I've illustrated stories about everything from leachate ponds to rat fishing.

Every time I get an assignment, I listen to the instructions, ask as many questions as possible, and then listen to the answers—closely! And this may happen a few more times before I'm ready to go to work. Sometimes you'll get a story that's already written and available for you to read—but not always. Sometimes you have to fly blind. The art director may have little more than a headline or a short description of the writer's intentions; the death metal band may have only the title for their next CD and a vague idea of a song list; the company may have a new product coming out but not be quite sure about the direction the campaign is going to go in. As an illustrator, your job requires that you get as much detail out of your client as possible. You have to listen carefully and ask yourself if it sounds like, or feels like, you've got all the information you need.

Although most communicating these days is done via email, you may find yourself in a face-to-face meeting or on the phone with a client. Take notes! Get the story straight. This doesn't just apply to content. Be sure you get all the pertinent specifications for the job: size, orientation (vertical or horizontal), whether the illustration will be color or black and white. It's crucial. And make sure your final art is proportional to the size the client needs. If you don't do these things—and I mean *religiously*—you'll find yourself with a piece of art that you worked very hard on but that the client can't print. You will not get paid. And, in a related note, you won't ever work for that client again.

DEAD BABY WITH MOTHER, INK ON PAPER. PUBLISHED IN THE *WASHINGTON CITY PAPER*.

death. The paper didn't want to use a photograph, and they didn't want me to illustrate the actual people, so I had to find a way to show them without showing them. That's why I chose to crop out the face of the mother. I live in Baltimore, and the clothing styles here aren't dissimilar from the styles in D.C., so to prep for this job I walked around my neighborhood to get an idea of what the mother's contemporaries were wearing. The outfit in the image on page 46 was a fair approximation of that look. But the editors at the paper thought she looked too "slutty" and wanted something a bit more modest. So, despite my disagreeing with the editors' opinion, . . . I did the piece above. It's essentially the same. Nothing was lost in terms of character, tone, or

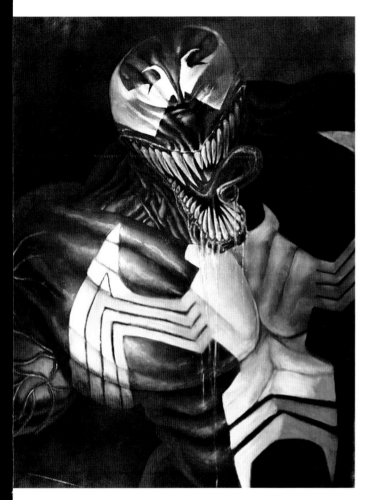

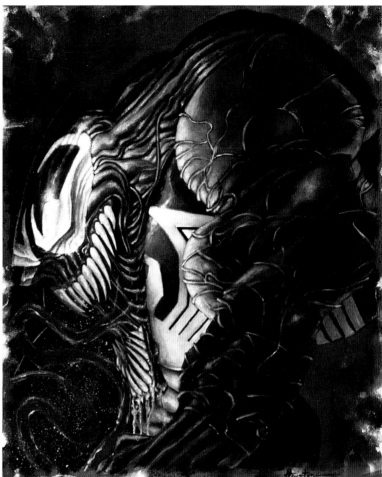

VENOM 1, ACRYLIC ON CANVAS BOARD. FOR MARVEL COMICS.

VENOM 2, ACRYLIC ON CANVAS BOARD. FOR MARVEL COMICS.

information, so if my client was happier with this one, that's fine with me. (Bonus: They paid me twice!)

Another example: For a proposed series of posters for Marvel Comics, I was assigned the character Venom. Not having done a piece like this for Marvel but knowing they had pretty strict guidelines about how their characters were depicted, I tried to hew to what I believed would be an acceptable convergence of my style and the client's taste. While the client liked the piece, ABOVE LEFT,

overall, he felt I'd missed an opportunity to do something more aligned with my unique vision. I zigged, and they zagged! Who saw that one coming?

So I created a second version, ABOVE RIGHT, which both the art director and I felt was truer to my sensibilities. I liked the first one, but I had to agree with the client. The second is more interesting, so it benefitted from his point of view. (But in the end, the poster series never happened.)

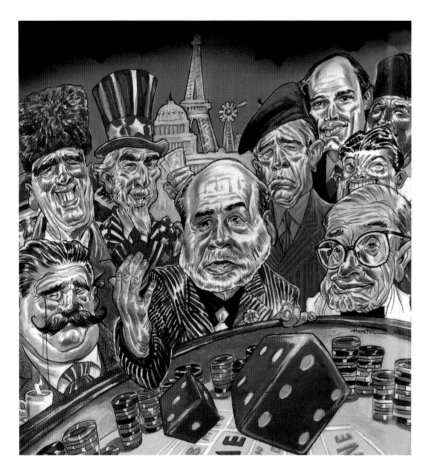

COVER FOR WILL BONNER, *DICE HAVE NO MEMORY: BIG BETS AND BAD ECONOMICS FROM PARIS TO THE PAMPAS* (HOBOKEN, N.J.: JOHN WILEY & SONS, 2011).

paintings of dogs playing poker. The idea was to show dogs representing a variety of countries playing roulette. The publisher, however, wanted people. This conceptual tug of war happened without me in room, but after I'd completed (and was paid for) two sets of detailed sketches, this is what we came up with. While I liked the other idea better, this one works fine. They also asked that I remove a hat that was originally on the guy behind former Federal Reserve chairman Allan Greenspan, at front right. I did. Problem solved.

The pieces OPPOSITE were for a wraparound cover for a novel entitled *The Last Goddam Hollywood Movie*. The image at top left is the original. It was a very close approximation of the sketch, and I thought it came out pretty well. For whatever reason, the art directors chose to flip the image (bottom, left), so that the dog's face was on the back of the book. They also chose to add some dust under the dog. So the front cover basically looked like the right-hand image, but with lots of big, chunky text superimposed on it. Was it a good call? Well, it was their prerogative.

The piece ABOVE was actually a job for two clients: Agora Financial (the company that hired me) and the book's publisher, John Wiley & Sons. Agora, which is owned by author Will Bonner, wanted a cover that spoofed those

COVER ILLUSTRATION FOR JOHN SKIPP AND CODY GOODFELLOW, *THE LAST GODDAM HOLLYWOOD MOVIE*
(PORTLAND, ORE.: FUNGASM/ERASERHEAD PRESS, 2013). TOP LEFT: FIRST VERSION; BOTTOM LEFT:
SECOND, HORIZONTALLY FLIPPED VERSION; ABOVE RIGHT: FINAL VERSION FOR FRONT COVER.

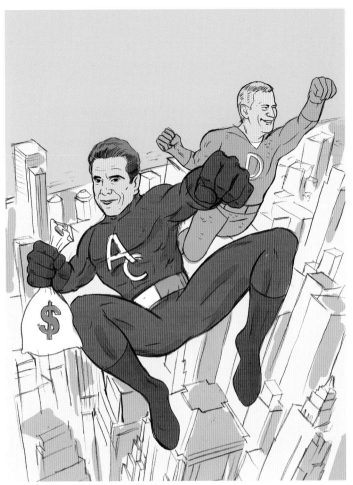

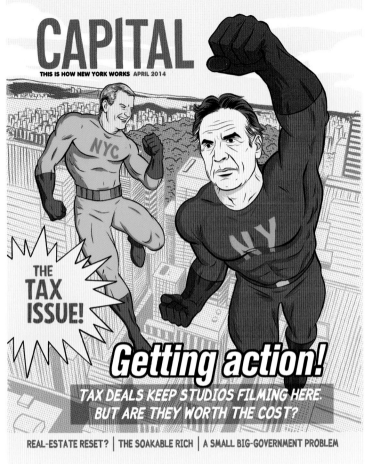

ALEX FINE, COVER ILLUSTRATION FOR *CAPITAL NEW YORK* MAGAZINE. LEFT: ORIGINAL VERSION; RIGHT: THE REVISED VERSION, PUBLISHED IN THE APRIL 2014 EDITION.

Now look at the two versions, ABOVE, of a cover created by Alex Fine for *Capital New York* magazine. The one at the left is the original. Pretty nice, right? And yet the client asked for a change. According to the client, the figure of New York governor Andrew Cuomo, at the front, was showing "too much crotch." So Alex produced the version at right. Is it better? Despite the paucity of crotch, Alex thinks the art director made the right call.

Nothing should leave your drawing board unless you're satisfied that it's the best piece it can be. Just understand that the best piece isn't necessarily the piece that suits your own taste. Learn to establish a healthy critical distance from your work. Don't fall in love with it. Nothing is worse than an illustrator with a broken heart.

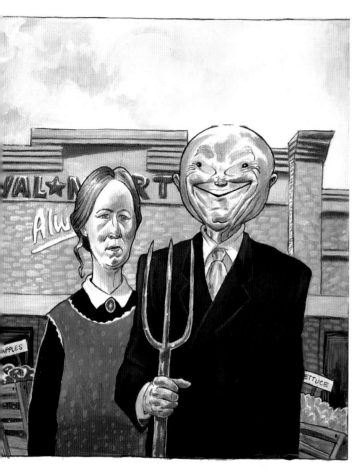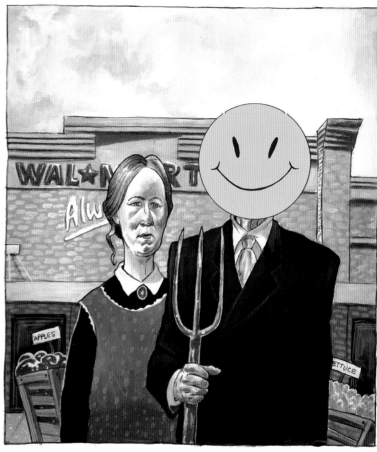

WAL-MART COUPLE (SKETCH, LEFT, AND FINAL, RIGHT), ACRYLIC AND INK ON PAPER. PUBLISHED IN *CITY PULSE* (BALTIMORE).

This illustration was commissioned by a paper called *City Pulse*. The story was about Wal-Mart working with small farmers. The art director wanted an American Gothic couple (again), with the man replaced by the Mr. Rollback character from Wal-Mart's ad campaign. I originally pitched the idea of turning the small farmer into Mr. Rollback. Although they initially agreed to my concept (and sketch), they insisted that the final image show the woman and Mr. Rollback, so I slapped a smiley face on him and, well, there you go. Better? Worse? You be the judge.

WITHOUT AN IDEA, WHAT HAVE YOU GOT?

Developing Concepts for Illustrations

SO FAR, I'VE SPOKEN A LOT ABOUT WHAT IT TAKES to be an illustrator, but I haven't talked so much about what it takes to make an illustration. I'm talking about the nuts and bolts—the actual making of the work.

The best place to start is probably the *concept*. Let's focus here on editorial illustrations, which help explain an article's concept to the reader. With these jobs, the task for the illustrator is to boil down the elements of the story/message/idea into an image that will communicate the gist to the viewer.

Sometimes, an effective concept can be pretty simple. Opposite is a piece I did for the *Baltimore Sun* for an article about decorating for Christmas. The article was lighthearted, so I chose to go with a goofy character in a cartoonish style. Exaggeration was the key: Who doesn't feel like their Christmas-light strands magically multiply the second they come out of the box?

When you're creating an illustration, there's a chicken-or-egg dynamic. The elements that come together to make a successful illustration are intertwined. It's tough to talk about concept without also talking about color or composition or stylistic choices. So, as we touch

CHRISTMAS LIGHTS, ACRYLIC, COLORED PENCIL, AND INK ON PAPER. PUBLISHED IN THE *BALTIMORE SUN*.

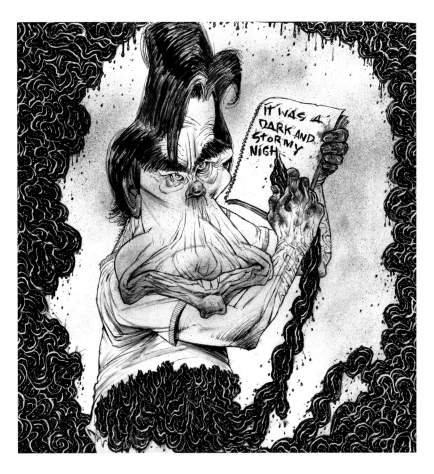

STEPHEN KING, INK ON PAPER. PUBLISHED IN THE *WASHINGTON CITY PAPER*.

My job was to take the writer's concept and create a visual. So what elements could I work with here? Stephen King. Writing. Horror. And which of these things have visual associations to exploit? All of them.

Unlike a lot of authors, Stephen King has a face that's well known and, to put it kindly, super unusual—thus the caricature. He's a horror writer, so including something comically gross—writing with his guts—made sense, *and* it worked on another level, because the author of the piece was arguing that King's work comes "from the gut" (in a less literal sense). The "dark and stormy night" phrase is a goof on the old trope about bad writing, and since the piece cited King's critics, it seemed like a fun way to turn the trope on its head. And because the article was written in a breezy, comical style, this image matched it tonally. I didn't need to include any other visual allusions to support the writer's argument, because it wasn't necessary to communicate the whole of the article. Any more would have been overkill. Balance in concept is just as important as balance in composition or color.

The piece OPPOSITE is a *narrative illustration*. A peace rally was held in Washington, D.C., and ironically,

on any one of these things, the others will inevitably pop up, like Jason Voorhees at the end of a *Friday the 13th* movie.

The piece ABOVE was for an article claiming that novelist Stephen King is an underrated writer. True? False? As an illustrator, my job wasn't to agree or disagree.

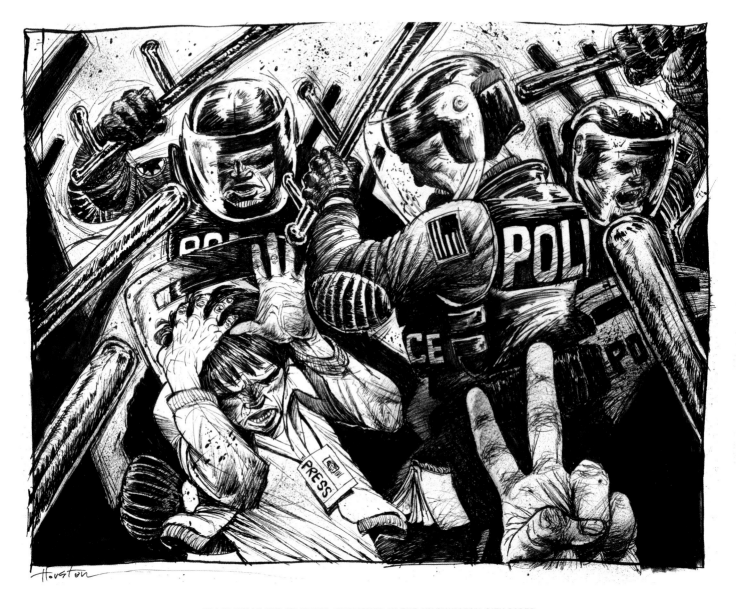

PEACE RALLY, INK ON PAPER. PUBLISHED IN THE *WASHINGTON CITY PAPER*.

violence broke out. I felt that illustrating the melee that ensued was more powerful than coming up with a more conceptual image like a dove with a black eye or something. The black-and-white scheme allows the viewer to easily distinguish the black-uniformed cops from the reporter. The heaviness of the blacks helps to visually overpower the reporter, and the hand giving the peace sign in front "pops" against the brutality of the action behind.

BLIZZARD 1995, INK AND WHITE INK ON PAPER. PUBLISHED IN THE *WASHINGTON CITY PAPER.*

ABOVE is an illustration I did for an article about the different effects the blizzard of '95 had on the haves and the have-nots in Washington, D.C. The writer described a city in which the affluent weathered the storm with relative ease while the poor found themselves in a hellish, third-world environment. Doing this in black and white allowed me to play the figures against the snow. The hairy line makes the main character look haggard and tortured, and the border here was necessary to contain the piece and keep the snow "locked in." (I'll talk more about borders in chapter 7, on composition.) The illustration's overall messiness gives it a distressed quality, which I thought conveyed the idea of total breakdown.

The concept for the piece OPPOSITE LEFT is that lawyers can be as slippery as snakes when it comes to using

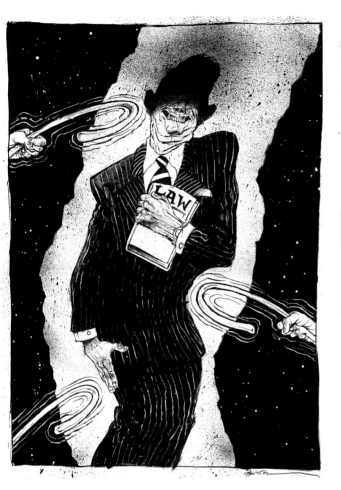

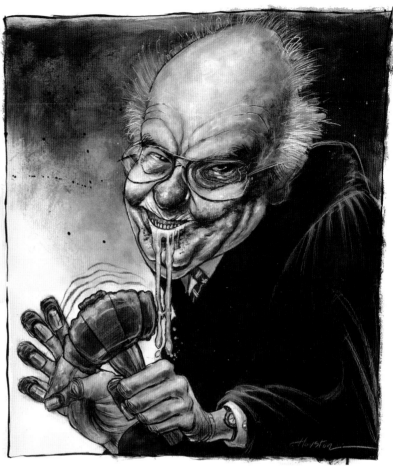

LAWYERS, INK ON PAPER. PUBLISHED IN THE *WASHINGTON CITY PAPER.*

JUDGE, ACRYLIC AND INK ON PAPER. PUBLISHED IN *NEW TIMES LA.*

the law to skirt ethical issues. This is an example of a piece in which the concept is really pushed by the compositional elements. By creating a curving shaft of light that echoes the shape of the twisting character, I emphasized the ideas that lawyers are both reptilian and difficult to pin down.

Let's stick with the legal theme. The illustration ABOVE RIGHT was for a piece about a sleazy judge who had

engaged in some unfortunate activities. I did a caricature of this gruesome jurist and used everything from the color of his flesh to his posture to the drool dripping from his mouth to give the viewer the impression that this guy was sleazy. I even decided to sexualize the gavel—a typical judge's prop—to really push the ick factor.

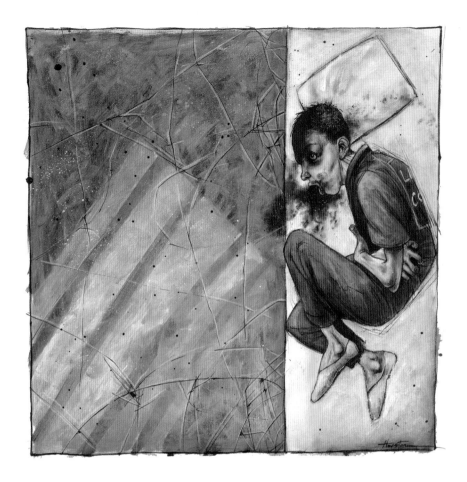

DEATH IN A CELL, ACRYLIC AND INK ON PAPER. PUBLISHED IN *NEW TIMES LA.*

OPPOSITE: *POLITICAL MACHINE,* INK AND COLORED PENCIL ON PAPER. PUBLISHED IN *CLEVELAND SCENE.*

The piece ABOVE, which like the previous one appeared in *New Times LA,* was a cover for a story about a boy who died mysteriously while in jail. I composed the piece so that it created a small box (the cot) inside another box (the cell) inside another box (the frame). I wanted the image to feel geometric and cold in both color and space. I also exaggerated the boy's anatomy to make him look very skinny and to emphasize how he has rolled into a ball as he convulses. I wanted the viewer to feel the character's isolation and vulnerability.

Politics is the subject of the illustration OPPOSITE. Because it was a cover, it had to be constructed to accommodate the newspaper's banner and other cover text. (I'll say more about illustrations with text in chapter 7.) The concept was to show the consummate political machine, complete with campaign slogans, spin, and multiple hands for shaking. It's spewing empty rhetoric and is partly held together with red tape. It also looms threateningly over the average voter (the guy on the cliff).

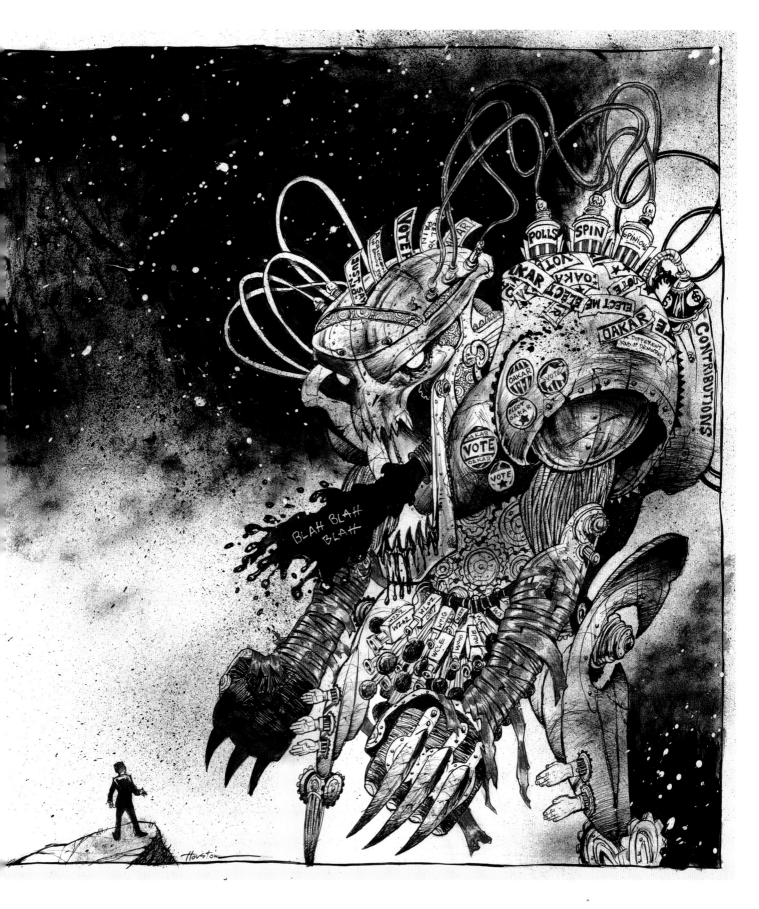

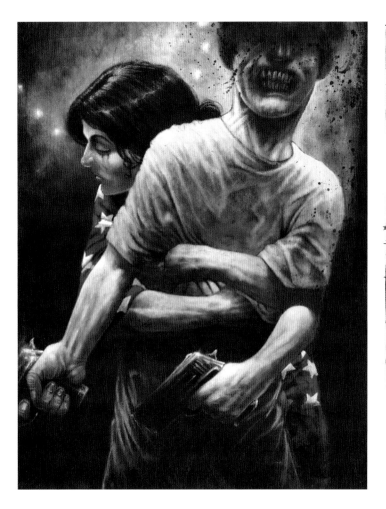

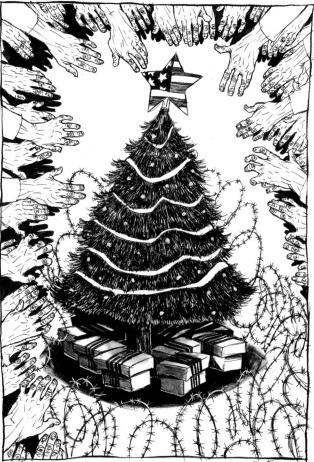

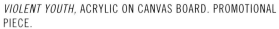
VIOLENT YOUTH, ACRYLIC ON CANVAS BOARD. PROMOTIONAL PIECE.

CHRISTMAS TREE, INK ON PAPER. PUBLISHED IN THE *HOUSTON PRESS.*

I wanted to do a promotional piece about kids who are ill equipped to deal with their anger and the violent ends they can go to to make a statement. The concept in the illustration ABOVE LEFT is that the woman, who represents both mothers and America, is trying to hold onto her son to prevent him from engaging in a deadly act. I wanted to juxtapose her sad, determined face with his, which is twisted by rage into a monstrous visage.

The piece ABOVE RIGHT was one of a series of illustrations that accompanied a story about the problems that Texas municipalities were having with illegal immigration. There was a line in the story about immigrants viewing the United States as a Christmas tree. I liked that metaphor, so I decided to show the United States as a tree, with presents beneath it and surrounded by barbed wire. The hands represent the people who want access to America's gifts.

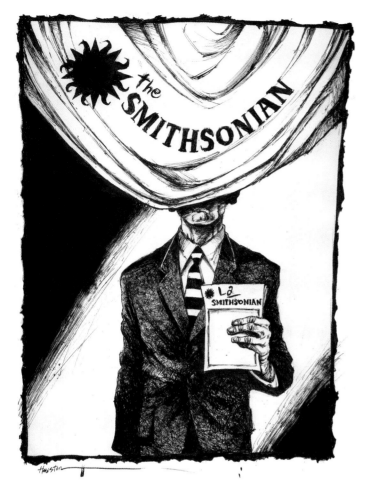

LA SMITHSONIAN, INK ON PAPER. PUBLISHED IN THE *WASHINGTON CITY PAPER*.

BLACULA, ACRYLIC ON CANVAS BOARD. PROMOTIONAL PIECE.

The illustration ABOVE LEFT was challenging because the story didn't especially lend itself to visual interpretation. It was about the Latino community's feeling ignored by the Smithsonian Institution. In response, the Smithsonian put out a Spanish-language publication called *La Smithsonian,* but the Latino community was not entirely appeased by this effort. The trick was to communicate this. My concept was to show a guy holding up his tiny magazine only to have the large curtain bearing the Smithsonian's logo obscuring his face (and nationality)—a visual metaphor for a crumb being thrown to him while a much grander (Anglo) representation of the museum pushes him into the background.

I'm a huge fan of blaxploitation cinema of the 1970s, so I wanted to do the portrait of Blacula ABOVE RIGHT.

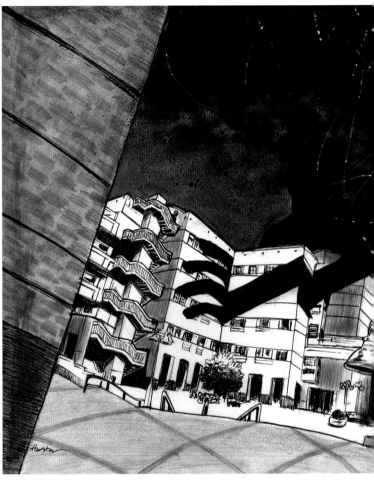

BALTIMORE/WASHINGTON INTERNATIONAL AIRPORT AD, INK ON PAPER. FOR EISNER AND ASSOCIATES.

SUICIDE BUILDING, ACRYLIC AND INK ON PAPER, WITH DIGITAL COLOR MATCHING. PUBLISHED IN *OC WEEKLY*.

The film *Blacula* was made (and took place) in 1972, so the concept was to incorporate 1970s-era elements, including disco. I roughly reproduced the design of the smokestack in the logo of the TV dance-party show *Soul Train* while changing the color palette. I also opted to use Blacula's cape as a design element similar to that in a Dracula piece I'd done earlier (see page 24). Why use that particular piece of his wardrobe? Because, as a dude in the film says to Blacula, "Man, that's a baaaaaaaad cape!"

I'm sneaking in an advertising illustration ABOVE LEFT because, while not editorial per se, the image had to connect with a very specific point of view—commuter flights are, but shouldn't be, a bruising experience—and therefore took on an editorial tone. This illustration was one of a series of three that I created for Baltimore/Washington International Airport (BWI). The concept was to show harried, rumpled, distressed characters who would be better served if they used a

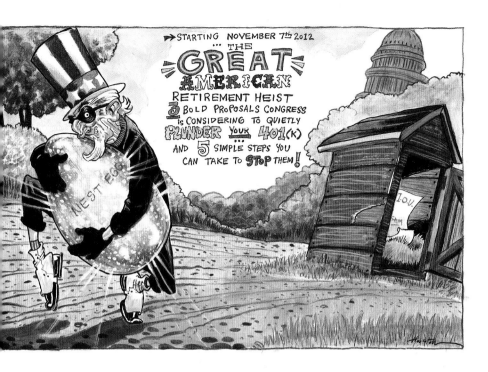

RETIREMENT HEIST, ACRYLIC AND COLORED PENCIL ON PAPER. FOR AGORA FINANCIAL.

commuter flight going through BWI. This is one of the few advertising jobs I've had, and it came my way specifically because I tend to draw unhappy-looking people. I wanted this guy to appear as though a giant had just squished his head with his thumb. The hairy line, spastic pacing, and general discomfort of the characters worked: I won the local and regional ADDY awards for this assignment.

The piece OPPOSITE RIGHT was a cover illustration for a story about an unstable guy who left a hospital and immediately made his way to a college campus, where he climbed several flights of exterior stairs and jumped to his death. The focus of the story was the buildings themselves, as magnets for suicides. The art director wanted to go with a weird, shadowy figure looming over the building. This is pretty straightforward conceptually and that's okay. Not every piece has to have a brilliant concept or device. The whole piece works because of the composition, limited color, and the stark stylization of the figure against the realistic architecture.

Just one more. The piece LEFT was for a website's landing page, and it's about retirement advice. The piece includes text that actually tells the story, so, as an illustration, it's a bit of a cheat. Still, the image had to work, and the concept—Uncle Sam stealing a nest egg—had to read easily and clearly. Bright colors, a recognizable character, and the setting work together to interest the viewer and get them to read the story.

I hope this chapter has gotten you to think about concepts. Ideas for illustrations are as varied as the subjects themselves. Sometimes the concepts are yours, sometimes they're the client's, and sometimes it's a collaborative effort. But no matter where they come from, without a concept to illustrate, you're just making pictures.

DO A CONCEPTUAL, CHARACTER-DRIVEN ASSIGNMENT

This is an assignment I like to give to my students: Imagine that there are two places. One is called Sklangston. The other is called Ephemeralia. Your assignment is to pick one of these places and depict someone who lives there. The piece can be of any size and either horizontal or vertical in format. It should be full color. Also, along with the inhabitant, include a setting (some indication of the environment) and one prop.

When I give assignments, I always try to explain the logic for the job. I think you learn more when you know *why* you're doing something. So here's the logic for this assignment: Whenever you do an illustration that includes an environment or character, you're *creating* both. You're designing every element—the character's hair, clothes, skin color, anatomy, and demeanor, and the environment's flora and fauna, architecture, and weather. If the illustration is rooted in a real time and place, you're responsible for accurately depicting that setting. If you're illustrating a real person, then you're obligated to capture that person's likeness. But if you're illustrating a person who doesn't exist, you'll need to think about how they'd look, feel, move, dress, and so on. If it's a place you're imagining, then what kind of trees does it have? What do the dwellings look like? What kind of sky covers it? You're creating a universe, and it needs to have an internal logic that's consistent, or it won't work.

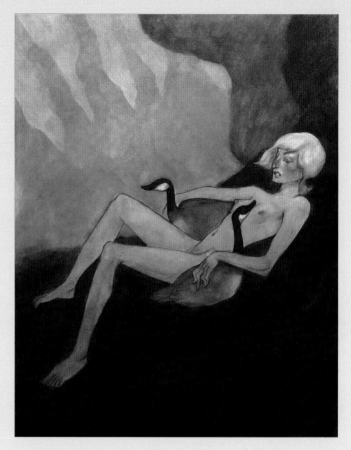

ALISON GEORGE, *EPHEMERALIA,* WATERCOLOR, BALLPOINT PEN, AND ACRYLIC ON PAPER. CLASS ASSIGNMENT.

This assignment gives you the opportunity to create a character and environment totally from your imagination. The only clue regarding what these folks and their environments might look like comes from the names of the places—Sklangston and Ephemeralia. Say the names out loud a few times. What do they sound like? What kind of person would come from a place called Sklangston? Ephemeralia? What clues do these names give you?

Consider colors. What do they say about the person and environment? Think about the kinds of lines you'll use— rough? smooth? linear? blocky? curvy? sharp?—

or the way you'll apply the paint. What is the person doing? And don't forget the prop: Is it useful? How would it be used in that environment? What does it say about the person you're depicting? Is he or she a worker? Upper class?

To help get you started, I'm including illustrations two of my students created for this assignment. I hope that you'll find them helpful, but don't lean on them. That would be cheating. Being an illustrator means being an original thinker.

OPPOSITE is Alison George's version of Ephemeralia. The nude woman, shown in a relaxed position, gives the impression of an easygoing, languid existence. The soft, cool colors give it a placid feel. The lack of clothing and simple landscape seem to indicate a pre-civilized or pre-industrialized surrounding. The geese (the props) unite the woman and nature, giving the piece a beautiful, fairy tale quality. And the internal logic of the piece feels consistent.

Tiffani Krajci chose to illustrate a denizen of Sklangston, RIGHT. The differences between this world and that of the previous piece are pretty obvious. Tiff imagines a world that, unlike Alison's Ephemeralia, is enclosed and cavern-like. She includes stalactites and stalagmites and uses icky green and yellow tones, and the dark area in the background suggests a cave or underground environment. The character is crude and monstrous. Unlike the woman in the last piece, this guy is depicted in a confrontational pose. His head is a little too big for his body. He's slightly hunched. His ribs show. His hair is wild, and his clothes and facial adornments bring to mind some kind of tribal society.

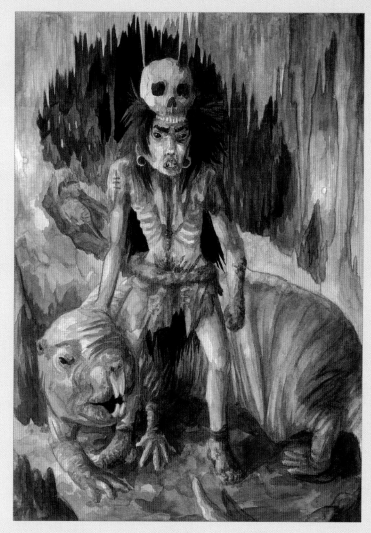

TIFFANI KRAJCI, *SKLANGSTON,* WATERCOLOR ON PAPER. CLASS ASSIGNMENT.

The prop is a hideous creature—a huge, hairless ratlike thing. Maybe it's a pet. Maybe it protects him. Whatever it is, it's ugly, and so is the world Tiffani created. Yet at the same time it's as successful as the previous piece—well executed, smart, and with a consistent, appropriate internal logic.

Now it's your turn. Go!

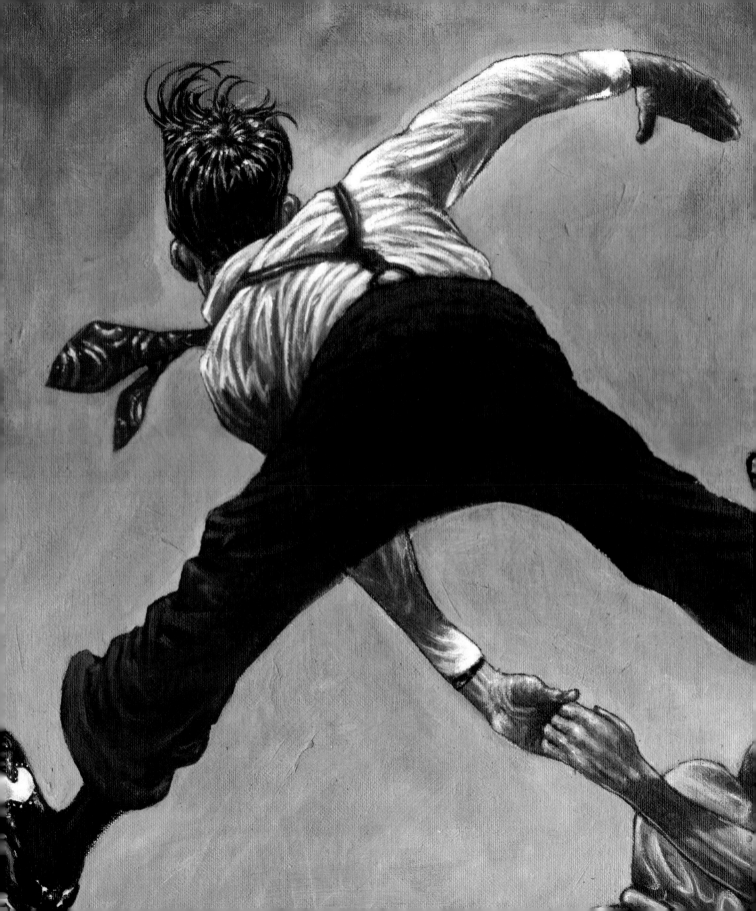

PAINTBRUSH? PEN? NEEDLE AND THREAD?

Exploring Mediums for Illustration

CONGRATULATIONS! You're officially hip to the concept of conceptualizing. Now what are you going to do? How do you get your ideas from your head onto a piece of paper, a canvas, or a computer screen?

In this chapter, we'll talk about mediums. Once, painting in oil was all the rage. Then acrylics were invented—and, boy, am I glad they were. Acrylic paint is *easily* my favorite color medium. I used it for the piece opposite, called *Jump,* which was for a series illustrating Swing Era dancing.

Some illustrators, however, favor pastels or watercolor. Colored pencils, pen and ink, dyes, cut paper, silkscreen, soft sculpture, collage, gouache—they're all fair game. I recall when people first started using airbrushes, back when I was in college. They were pilloried for it, but hey, it worked for them. And, of course, these days it's all about digital art.

All of these mediums are valid, and each has its pros and cons. Try them all. See what works best for you. Ideally, you'll become proficient in a number of them, which will enable you to evolve stylistically in many directions, and the more stylistic solutions you can offer, the more jobs you can handle. Some people disagree. They believe that you should do one

JUMP, ACRYLIC ON CANVAS BOARD. PROMOTIONAL PIECE.

thing really well and keep churning it out. They have a point. Certainly there are lots of examples of artists who tread the same ground for their entire careers—Walt Disney comes to mind. But it seems to me that the wider the net, the larger the catch.

Let's look at a few illustration mediums, even including a few I don't use but that a lot of illustrators do.

OIL PAINT

Although he has dabbled in illustration, Ron Roberson is not primarily an illustrator. So why am I beginning with him? Well, number one, his work is clearly amazing, as you can see from the example RIGHT. And, two, because it's easy to see how this personal piece could have been created as an illustration. According to Ron, he had some dramatically lit life drawings that he wanted to combine into a single painting. He was looking to create a mysterious place outside time. So while the story isn't as straightforward here as it would be in a typical illustration, the lighting, colors, composition, and setting are specifically chosen to

Line! Color! Action!

RONALD X. ROBERSON, *INVOCATION,* OIL ON CANVAS. COURTESY OF THE ARTIST.

communicate the mood that the artist is trying to achieve. Because it's a slow medium, artists who use oil paints can be deliberate when creating their work. It's also great for working large, because the colors can be mixed and pushed around for a long time before drying—unlike acrylic, which dries so quickly that it can be hard to match colors. Notice the depth achieved in this piece. That plus strong, vibrant colors are among the reasons some illustrators prefer oil. While I am no fan

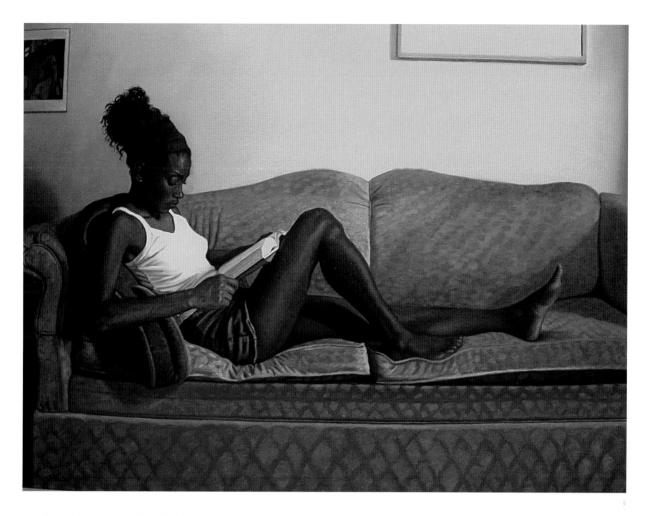

JAMES H. HOSTEN, *SUNDAY MORNING,* OIL ON CANVAS. COURTESY OF THE ARTIST.

of the medium, I am absolutely a fan of work that turns out as beautifully as this.

The lovely genre painting ABOVE shows James Hosten's mastery of the oil medium, allowing him to explore the subtlest shadows and textures. His composition—particularly the placement of the pictures on the wall—creates a soft tension that gives a dynamic quality to an otherwise still piece without impinging on the overall sense of tranquility. While it wasn't created for a client, I think this is a great illustration. The artist intended to show a person—in this case a young woman who happens to be black—doing the same normal, mundane things on a Sunday morning that any other young woman might do. By creating an image rife with ordinariness, he succeeds in illustrating his point—people are people. They do the same stuff. They act the same way. It's a statement by way of understatement, and it couldn't be more beautiful.

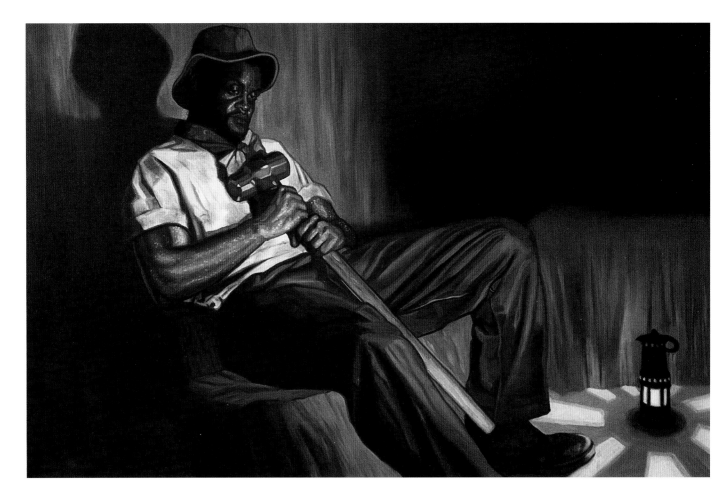

JAMES H. HOSTEN, *JOHN HENRY: HE WON THE RACE/LOST THE BATTLE,* OIL AND ACRYLIC ON STRATHMORE BOARD. COURTESY OF SRA (MACMILLAN/MCGRAW-HILL).

ABOVE, Hosten combines oil and acrylic to illustrate a proud, exhausted John Henry at the climax of the famous folk tale. You may recall that, in the story, John Henry was a steel driver who raced a steam-powered steel driver. He won the race but then died of a heart attack, clutching his hammer in his hand. As in the preceding image, Hosten is using directional lighting, but here the light defines much harder shadows; together with the strong diagonal tilt of the character's body, this creates a very dynamic composition. The character appears to be caught in a moment of reflection, and the powerful combination of light and composition underscores the moment.

ACRYLIC ON CANVAS

I'm just going to come out and say it: I love acrylic paint. I work very fast, and acrylic dries very fast. Unlike oil, which can stay wet longer than the entire run of your favorite sitcom, acrylic moves like lightning. It's true that some artists don't like that aspect of the medium. It makes it hard to match colors, which can be a problem. Because the paint dries so quickly, it's not prudent to mix huge mounts of any particular color since it may dry before you can use it all. However, you may need to cover a large area. When that's the case, you may find that the color you've applied to the canvas is slightly different from the version you're mixing to finish off the area. And the colors can also dry darker than you might expect. Acrylic's not for the faint of heart, but for someone who has to meet deadlines, I can't think of a better wet medium.

You can use acrylic paint on either canvas or paper. What's the difference? Obviously, the difference has to do with the surface. Paper and canvas react differently to the paint: Paint tends to sit on the canvas's surface, while paper absorbs it. Instead of using a stretched canvas, I often work on canvas board. When doing so, I first put down a field of neutral color and then layer my paint on top of that field. Although the act of painting is one of addition (you're adding layers of paint), I think of it

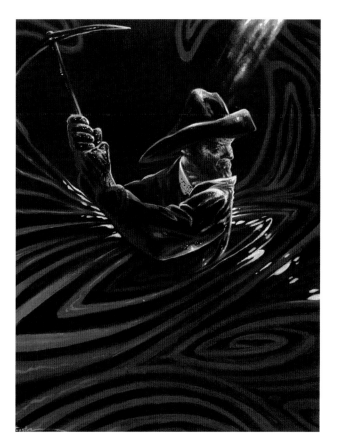

OIL MAN, ACRYLIC ON CANVAS BOARD. PROMOTIONAL PIECE.

as subtraction. I rough in large, monolithic shapes that represent my characters and then proceed to uncover the finer details within those shapes by adding paint. It's like taking the proverbial block of stone and chipping away until you find the statue inside. I'm chipping away at the blocks of color, defining them with layers of paint. Along the way, I add washes of color to flatten the areas I've painted, and then I go back and continue to define the contours. Eventually, when I put in the last highlights, I've found the image that was buried within.

The piece ON THE PREVIOUS PAGE is acrylic on canvas board. I was inspired to do it after seeing the 2007 Paul Thomas Anderson film *There Will Be Blood*. I was captivated by a scene in an oil well in which the entire image is black on black. I wanted to re-create that feeling of slick, oily darkness, but I needed a story. I elected to incorporate this image into a larger concept and illustrated a series of men—including a coal miner and a firefighter—essentially disappearing into their work environments. Here, you can see how the acrylic paint allowed me to create very deep, very dark areas (including the character's hat and slicker) that appear to be black but are in fact many colors mixed to look black.

On canvas, acrylic paint has a heft and dimension that I don't get in other mediums or on other surfaces. For the illustration called *Jump* that introduces this chapter (page 68), I wanted that dimension so that the character would have a weight that would work as a counterpoint to the space. By giving him a sense of real heaviness, I wanted to emphasize the athleticism required to get to that height—to capture the spirit of swing dancing. In the piece ABOVE RIGHT, however, I used the weight in a completely opposite way. Even though the water is fairly dark, the viewer knows what it is and how it behaves—and knows, further, that a body in water floats. The image is still but is also somewhat

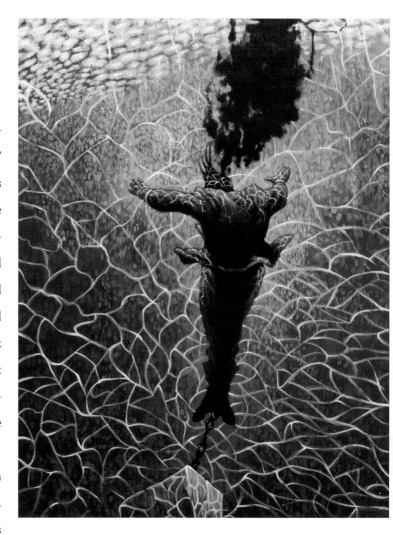

MICHIGAN LAKE, ACRYLIC ON CANVAS BOARD. PROMOTIONAL PIECE.

tense, because the body, tethered to the concrete block, cannot bob up as you'd expect.

The piece OPPOSITE LEFT was painted with a "dead" brush—a brush that had been mashed into submission (as tends to happen when I paint), leaving very few bristles. Using this brush gave a harsh quality to the paint and a brutish quality to the character. I painted it in a much heavier way than usual, and the layers of paint

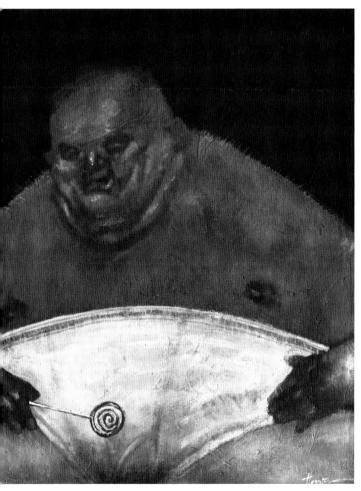

PERVERT, ACRYLIC ON CANVAS BOARD. PROMOTIONAL PIECE.

A GENTLEMAN WITH WORRISOME IDEAS, ACRYLIC ON CANVAS BOARD. PROMOTIONAL PIECE.

show through, giving the piece a grubby, unfinished quality. The hands and crotch of the underwear are red and grungy to emphasize the "weapons" of the pervert/molester. Using a rough, broad style, I kept the face vague. This isn't a real person. He's a representation. So his personality comes through via the style and paint application, not in his face (as it would in a portrait).

ABOVE RIGHT is a piece from my *Gentlemen* series. Here, the acrylic paint allows for a certain reality in the color, texture, and dimension of the face that I can play off against the flat areas. I'm able to build up the background with multiple layers of various colors so that it's multicolored while also appearing to be white.

CD COVER FOR VORTEX OF CLUTTER'S *GHOSTS OF A NEW GENERATION,* ACRYLIC ON CANVAS BOARD.

For the CD cover ABOVE, The Turkish death-metal band Vortex of Clutter explained the concept of their album (capitalism destroying mankind) and left it to me to come up with an image. The canvas board provided texture and gave me a surface on which I could layer paint to create depth in the void in which this poor guy sits. I played around with the anatomy and extended the guy's neck a bit to emphasize the gold forcing its way up through his throat.

ACRYLIC ON PAPER

When painting with acrylic on paper, I don't put down a field of color. Instead, I use acrylic like watercolor: Rather than creating white with paint, I keep the white of the paper as my highest highlight and fill in around it. But I use much darker colors than I would with watercolor. Also, I sometimes add ink or colored pencil to these pieces, which I don't do when working on canvas board. (Although if you want to, that's fine.) To me, painting on canvas board is painting, and painting on paper is a combination of drawing and painting. I like the stylistic differences that both allow, so I keep them separate.

For assignments, I tend to use acrylic on paper a lot. This is partly because it's what clients want and partly because it's practical. Not only is it faster, but it's easier to scan work on paper (a big consideration these days).

I did the illustration RIGHT for an article about the guys who wrote the Harry Potter films. I wanted a certain amount of energy and whimsy, and acrylic on paper gave the piece a lightness that I think served the subject matter. Although we haven't talked about composition yet, note the chair centered in the piece and the way it

HARRY POTTER WRITERS, ACRYLIC ON PAPER. PUBLISHED IN THE *BALTIMORE SUN.*

counterbalances the chaos around the character sitting in it. Also, the peak of the roof frames the character, as do the owls and donuts—a design concept we'll talk about later.

PRISON MELTDOWN, ACRYLIC ON PAPER. PUBLISHED IN THE *HOUSTON PRESS.*

IMPRINTS, ACRYLIC ON PAPER. PUBLISHED IN THE *CITY PAPER* (BALTIMORE).

The piece ABOVE LEFT was about a tense prison situation fueled by racial problems. This was a perfect piece for acrylic on paper because I wanted heavy and shocking colors (the red and green) while also being able to draw jumpy lines with colored pencil to add a sense of motion.

The concept for my cover for a special literary insert, ABOVE RIGHT, was the old saw about how an infinite number of monkeys typing on an infinite number of typewriters would eventually produce the complete works of Shakespeare. I used the acrylic as a wash, which allowed the colors to define themselves—in other words, wherever they landed, that's where I left them. Because the color is so light and essentially monochromatic, I was able to easily draw on top of it with both black and white ink. The viewer gets the sense of utter confusion, but the balance of color, line, and composition allows the piece to be read very easily. Also note that I used a splatter technique in this piece. Shakespeare never smelled so repugnant!

REPUBLICAN PARTY, ACRYLIC ON PAPER. PUBLISHED IN THE *CITY PAPER* (BALTIMORE).

BROOKLYN TAXI WARS, ACRYLIC ON PAPER. PUBLISHED IN THE *VILLAGE VOICE.*

The illustration ABOVE LEFT is similar to the monkeys-with-typewriters piece, but the line work is much heavier and I used colored pencil on the flag. The article it illustrated was about the unfortunate state of the two major political parties, and I wanted to use monochromatic color, heavy lines, and white painted areas to create a tired, distressed look. I could have accomplished this with acrylic on canvas board, but then I wouldn't have done the line work, and despite having many of the same elements, the piece would have felt different.

I wanted a level of realism for the *Village Voice* cover ABOVE RIGHT, so I played it pretty straight with technique and application. The gag is the irritation felt by the independent New York City cabbie as he's continually run over by those pesky new green cabs that now serve the city's outer boroughs. I chose a very static, cold color for the background and left the warm colors for the cabbie's face, as he's the one with whom readers will identify.

GOUACHE

Gouache (pronounced "gwash") is opaque watercolor paint. Heavier than transparent watercolor, gouache is applied—usually to paper or board—in much the same way as acrylic paint. But unlike acrylic, which can't be worked once it has dried, gouache can be moistened repeatedly, allowing the artist to go back and rework passages as necessary. It's also easier to get flat colors with gouache than with acrylic. It's been gaining in popularity for decades and is one of the mediums of choice for illustrators who like to work traditionally.

The image RIGHT is a good example of gouache in action. The style that Erica Ostrowski chooses to work in here is fairly simple, and the medium allows her to create these flat, attractive colors. While she includes beautiful design elements and active, interesting characters, the strength of the piece lies in the composition—the space and movement—and the color choices help underscore the action without getting in the way of the concept. It's exciting and fun but still easy to read.

The illustration by David Burton OPPOSITE LEFT gives you a pretty good idea of just how flexible the medium can be. Compare it to the piece by Erica Ostrowski and marvel at the difference in tone, attitude, and style. Unlike Ostrowski, who uses a thicker, flatter application,

ERICA OSTROWSKI, *WOLF KING,* GOUACHE ON RIVES BFK PRINT-MAKING PAPER. PROMOTIONAL PIECE.

Burton coaxes the watercolor effect out of the gouache. The softness of the tones and the limited color palette give the image an antique quality—perfect for a portrait of comic film actor W. C. Fields, who was born in the 1890s.

The image is grounded by the black Jack Daniels label and balanced by the colored billiard balls. I particularly love the crinkled quality of Fields's face. Burton

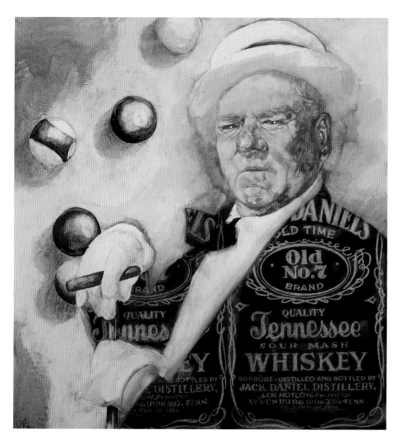

DAVID BURTON, *W. C. FIELDS,* GOUACHE ON BOARD WITH SWIRLED GESSO. PROMOTIONAL PIECE.

HOWARD PYLE, *THE DUNKERS—GOING TO MEETING,* UNDATED, GOUACHE ON PAPER. COURTESY OF YALE UNIVERSITY ART GALLERY.

started with a rough, sloppy underpainting on a gessoed surface with lots of brush texture. Using brushes, Q-tips, and water to bring up the details, he let the underpainting bleed color around the face and into other areas—as if he'd erased the paint to find a level beneath the surface. The inclusion of text, done with white and colored pencils, helps round out the story by giving additional information about the subject. (Fields liked to drink!) If these two pieces don't make you want to go out and buy a gouache set right now, you'd better check your pulse!

And ABOVE RIGHT is a gouache piece from the great nineteenth- and early twentieth-century illustrator Howard Pyle. It's worth noting how much dimension Pyle gets from his use of only black, white, and shades of gray, which give the piece a cold, overcast quality. By using the same gray for the sky and the shadows of the trees, he creates a believable winter and gives the viewer a small taste of the spartan life of the Dunkers, a religious group better known today as the Church of the Brethren.

MEG HUNT,
SEED-SAVERS,
MIXED MEDIA.
COURTESY OF
THE ARTIST.

MIXED MEDIA

Mixed media is a fancy way of saying that more than one medium has been used. By the strictest definition of the term, I'm using mixed media whenever I add ink or colored pencil to watercolor or acrylic pieces on paper. But I think true mixed media includes multiple mediums, each used generously throughout the piece. Collage, while not mixed media when simply incorporating multiple pieces of torn or cut paper, becomes mixed media when other elements—fabric, plastic, beads, string, and so on—are introduced.

The wonderful piece by Meg Hunt OPPOSITE is a fine example of an image created by combining various mediums. Hunt uses ink, gouache, and digital process to seamlessly illustrate this scene, including lots of elements while controlling the hierarchy of those elements.

The simple characters mesh beautifully with the vibrant colors to make a flat yet layered composition. The illustration is dynamic and fluid but still orderly, with the visual clarity needed to understand the story.

The image ABOVE, created by Bill Cotter for his children's book *Hello, Airplane!,* deftly mixes charcoal, graphite, and Photoshop. Cotter brings a fun, wide-eyed quality to the work while still keeping it simple and visually light—no simple trick. By using multiple mediums, he's able to incorporate things, like texture, that he might not otherwise have been able to exploit without the image getting heavy or gritty.

BILL COTTER, ILLUSTRATION FOR *HELLO, AIRPLANE!* (NAPERVILLE, ILL.: SOURCEBOOKS, 2014), MIXED MEDIA.

WATERCOLOR

Watercolor is a beautiful medium, and a lot of young artists are drawn to it because it seems fairly innocuous—unlike scary old acrylic or oil. It's often the first paint medium they turn to once they feel confident enough to move on from markers or colored pencils. But it's a tough medium to master and can break the strongest will if the artist doesn't have the patience to really learn how to control it.

The charming illustration RIGHT was created by Mitra Modarressi for her children's book *Stay Awake, Sally*. Modarressi's mastery of the watercolor medium is clear: She manages to find some hard edges in the otherwise soft piece, and the texture she creates in the raccoons' fur is a nice counterpoint to the aprons, mitts, clothes, cookie sheet, and bowl. The way she uses the paint to create an interesting and attractive wall and floor activates the negative space and makes it all one warm, engaging, cohesive environment.

OPPOSITE is another example of a watercolor illustration by a children's book writer-illustrator. Unlike Modarressi, J. Scott Fuqua is interested in action. A boy riding a giant raven while the USS *Constellation* floats by in the sky is nothing if not exciting. And Fuqua's image evokes a more realistic, messy world, much darker than Modarressi's. Painting in a controlled way in certain places but loosely in others, Fuqua says he's letting the medium "do what watercolor does best—details and large expanses of impressionistic washes."

MITRA MODARRESSI, ILLUSTRATION FOR *STAY AWAKE, SALLY* (NEW YORK: PUTNAM JUVENILE, 2007), WATERCOLOR.

J. SCOTT FUQUA, ILLUSTRATION FOR *CALVERT THE RAVEN IN THE BATTLE OF BALTIMORE* (BALTIMORE: BANCROFT PRESS, 2012), WATERCOLOR.

DIGITAL

I'm not a fan of computers—I've seen the *Terminator* films!—and I'm not well enough versed in them to do much more than scanning, saving, and sending my work to clients. Still, I can see the writing on the wall, and when the apes finally do take over the earth (yeah, I've seen those films, too), it's a good bet they'll be creating an awful lot of their illustrations on their computers. So it's probably not a bad idea to take a look at some examples of the high-quality work now being made digitally.

At RIGHT is an example of the incredible work a talented illustrator can create digitally. With his extensive training in traditional arts, Tom La Padula manipulates pixels as masterfully as he does oils. It takes a lot of skill to create the dimension and light seen here, and an average viewer would be hard pressed to identify this as a digital piece. Everything—from the sky to the clouds to the shadows on the planes and the smoke trail slashing through the air—is pitch perfect.

Compare the Daniel Krall piece OPPOSITE to the La Padula illustration. Both were created digitally, and yet they couldn't be more different in tone, color, subject matter, or style. Where La Padula takes a realistic approach, Krall follows a whimsical route. La Padula's illustration feels airy and open, but Krall jams in a mul-

TOM LA PADULA, *AERIAL DUEL,* DIGITAL IMAGE. PROMOTIONAL PIECE.

titude of figures and elements to create a completely different kind of dynamic. The edges of the piece can barely contain the action as his characters engage in an epic battle. Yet despite all the noise in the piece, Krall manipulates the eye, directing it through the action and never letting go of the thread of the story. Where La Padula saturates his image with strong, naturalistic colors, Krall de-saturates his, creating a nearly monochromatic illustration. And as with La Padula, Krall's strong foundation in traditional arts allows him to do all of this digitally very well.

DANIEL KRALL, *THE DRAGON BUTCHER'S DAUGHTERS,* DIGITAL
IMAGE. COURTESY OF THE ARTIST.

TEXTILES

Now let's veer into an even less traditional but no less worthy medium—textiles. Fabric may not be the first thing that jumps into your mind when you think about illustration, but there are a lot of fantastic illustrators who make their images using cloth. When done well, the results can be as brilliant as those created with any other medium.

The image ABOVE RIGHT wouldn't be nearly so intriguing were it a simple photo or painting. By using the unexpected medium of fabric, Kate Talbot imbues the image with style and a sense of humor. The client want-

ed to convey a warm, comfy vibe, so Talbot used wool as her primary fabric. The beautiful, handmade—and therefore slightly imperfect—bottles are surprising in an image related to an industry built on perfection. This counterintuitive approach is playful and provocative while still serving the client's interests.

In the charming piece OPPPOSITE, Talbot has chosen to work in flat fabrics cut and stitched to approximate a

JACQUELINE WADSWORTH, *ELEMENTS OF A HAPPY LIFE (YELLOW)—BAT AND LOTUS,* EMBROIDERY. COURTESY OF THE ARTIST.

KATE TALBOT, *PERFUMES,* CROCHET (WOOL) AND EMBROIDERY. PUBLISHED IN *STYLIST MAGAZINE.*

panel from an old comic book. The flatness nicely echoes the quality of a comic, and the black thread approximates ink lines. Talbot uses colors—including the pale yellow pieces that frame the bright colors—to control the eye and force attention to the center of the piece.

For the piece OPPOSITE LEFT Jacqueline Wadsworth chose the medium of embroidery, which dates back to ancient China, precisely because of its connection to the subject. While walking through New York's Chinatown district, Wadsworth saw some peasant folk-art embroidery, and it inspired her to illustrate ideas from peas-

ant culture while trying to replicate authentic Chinese embroidery stitches and appliqué. (For more illustrations from this series, see page 195.) While both Talbot and Wadsworth work with textiles, they shape the medium to fit their different visions, communicating concepts just as if they were sculpting, painting, or drawing. Respectively, these three pieces are akin to sculpture (*Perfumes*), drawing (*Round the Block*), and—because Wadsworth is working with shape, color, and volume—painting (*Elements of a Happy Life*).

KATE TALBOT, *ROUND THE BLOCK*, VARIOUS MATERIALS SEWN ON A COTTON BACKING, WITH EMBROIDERY. PROMOTIONAL PIECE.

INK

Now let's turn to the most basic medium of all—good old black ink. For anybody who really loves to draw—and that means all of you, I hope—it's nice when an assignment comes your way that requires that you stop and consider the world in simple black and white. No mixing colors. No worrying about how colors will play off one another. No concerns over your client's ability to print the colors accurately. No, sir, you just let that old black magic take over.

Alex Fine created the illustration ABOVE RIGHT to comment on the ongoing fighting between Israel and the Palestinians. The spare background and thoughtfully chosen elements—the cage, doves, and olive branch—combine to make a piece that deftly encapsulates a complex relationship spanning far too many decades.

There are lots of ways to make a black-and-white piece using ink. You can use a mechanical pen such as a Rapidograph or Micron. You can use bamboo shafts, sticks, or brushes. You can use a Sharpie marker. I usually use a crow quill (with a Globe nib) and Higgins Black Magic waterproof India ink.

This piece RIGHT was for a story about AIDS atients who were also addicts. They would get their meds from the clinic doctors then immediately sell them to push-

ALEX FINE, *UNTITLED,* INK ON PAPER. COURTESY OF THE ARTIST.

ADDICTS SELLING THEIR AIDS MEDS FOR DRUGS, INK, WHITE INK ON PAPER, WITH RAZOR CUTS. PUBLISHED IN *MIAMI NEW TIMES.*

ers for cheap drugs (heroin or crack). The pushers would then resell the AIDS meds. It was a tragic story and I wanted a tragic look for the piece.

INK DEMONSTRATION

You have to be careful when composing a black-and-white image. Take this one at RIGHT, for example. Here you have three shady looking characters grouped together. If they were all wearing solid black suits it could be hard to pick them apart, so I used multiple techniques to help define each guy. You'll note the solid black suit of the guy in front. A hard line on the left side (his right arm), coupled with a white area to indicate some light, helps him pop out from the guy immediately behind him. I also used a thin white line on his other shoulder to define his form and separate him from the guy in the hat. I used a gray wash and some line on the guy on the left hand side of the page to give a sense of space between him and his neighbors. Finally, I composed the image to make the guy in the hat very tall and white space between him and the other two. As a result, the height disparity creates some air and allows for a clear definition of the heads of the two guys in front.

It's not always necessary to use all of these techniques in the same piece—it can get a little too fancy and detract from the concept. Knowing that there are a variety of ways to illustrate a complicated black-and-white image and still have clarity, however, should allow you to conceptualize freely without the worry of technical limitations.

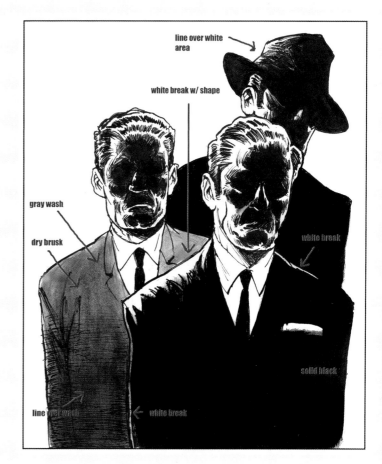

SCRATCHBOARD

Scratchboard is an unusual type of surface—usually thick paper or board covered with black ink, paint, or clay. The term *scratchboard* can also be used to refer to the technique in which an image is drawn by cutting into the surface of the board. It's basically an easy, modern kind of etching. Scratchboard doesn't always have to be black and white, but it very often is, so I include an example here.

At RIGHT is a piece by Warren Linn for a 1976 article that predicted the crime world of the year 2000. It's a great example of black-and-white work created using scratchboard. Instead of applying black ink to white paper, Linn subtracted black ink from the board's surface, revealing the white beneath. (Essentially, working on scratchboard is drawing with a knife.) Linn's beautiful line language defines the image, giving it a quality that ink line alone may not have captured.

WARREN LINN, *CHICAGO CRIME 2000,* 1976, SCRATCHBOARD. PUBLISHED IN *CHICAGO MAGAZINE.*

We've just scratched the surface of the mediums you might choose to work in. Whether you're painting, sculpting, collaging, working with colored pencils or pastels, making GIFs, or gluing bits of broken glass together, what matters is that you communicate the story, serve the concept, and meet the client's needs. Remember: In illustration, the medium is *not* the message, so if the medium you've chosen elbows the concept into the shadows, you need to refocus.

Finally: Yeah, I'm sure some smartass out there is pointing out that graphite pencil is the most basic medium of all. It's true—a lot of great illustrators do their finished pieces in graphite. But you don't really need me to teach you how to use a pencil do you? I mean, I'm giving you some credit.

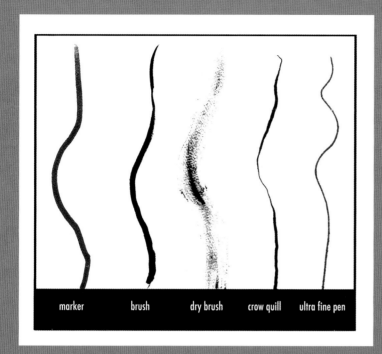

marker brush dry brush crow quill ultra fine pen

learn a language

LINE LANGUAGE—
YOUR LINES' EXPRESSIVE QUALITY

Each artist has his or her own *line language,* which is influenced by the type of tool used. Whatever you use to apply ink creates a specific line language: A mechanical pen or marker creates a neat, more uniform line that can be thicker or thinner depending on the size of the pen's tip and how the artist uses it. A brush can give an artist a faster line that can have a beautiful, "swooshing" quality, thick in some places and thin in others. A brush can also be used dry to achieve a scratchy look. A nibbed pen shares qualities of both the mechanical pen and the brush. It can go from very thin to very thick (depending on the size of the nib). It can also spit and splatter, which can add an interesting messiness to a drawing. Nibs come in different shapes and sizes, so they can produce an endless variation of lines.

Here's a tip: When doing a black-and-white illustration it's very important to prevent overlapping shapes from blending together. Be sure to separate adjacent dark areas with white line, light, space, or texture to keep them from merging into a dark blob.

The illustrations that follow were mostly created with a crow quill, though in some cases I used a hard-bristle brush or an ultrafine Sharpie marker. There's no right or wrong way to go about making a black-and-white piece; each artist has to decide which technique best serves his or her vision. As you look at these pieces, think about how many styles you can squeeze out of the same pen, nib, and brush. None of those materials costs much, so you can turn quite a profit on a black-and-white job if you know the score.

CHRISTMAS LUCHADOR, SHARPIE MARKER ON PAPER. PROMOTIONAL PIECE.

This was a holiday mailer for my illustration business. I used the Sharpie for this one. It's a pretty simple piece—a muscular wrestler hunched over in anger—but there's a lot going on in it. The line work is fairly bold, and the shading, while heavy, is restricted to certain areas. The blacks help define the character and also make the white areas that cross through the dark areas pop out. (Look at how the beard and hands stand out against the black shadows.) Even in a piece this simple, the areas of light and shadow have to be choreographed so that each can be seen and read by the viewer.

WHITE CHRISTIAN RAPPER, SHARPIE MARKER ON PAPER. FOR E! ENTERTAINMENT TELEVISION.

Another Sharpie piece. Normally, I like to put a border around my illustrations to define and activate the negative space, but the client's designer didn't want that. Like the previous piece, this is a pretty simple image, but it is much lighter, with far fewer black areas. Again, the line language helps define the character and tell his story, but you can feel the difference in tone—though both characters are goofy, one is more menacing.

FRACKING, INK ON PAPER. PUBLISHED IN THE *DALLAS OBSERVER*.

This piece was created with a crow quill and brush, with some ink washes added. The story it illustrated was about fracking in Texas, and it was not especially positive. I wanted to capture the essence of the story by doubling down on the background gloom with gray sky and dark clouds. The lines are both bold and light—easy to achieve with the mighty crow quill—and they stand out against the stark black of the Grim Reaper's shroud. The splatter behind the oil derricks and the pattern of small rocks visible in the cross-section of the earth multiply the textures and help create depth and dimension. All these elements form a visual language that, along with the composition, allows the viewer to see the images in an ordered way.

ANGEL OF DEATH, INK AND WHITE INK ON PAPER. PROMOTIONAL PIECE.

This piece was based on a story a friend told me about an encounter she'd had with a clearly unstable individual who claimed to be the angel of death. It's primarily crow quill, though the heavy dark areas were done with a brush, as were the lighter washed areas. I wanted to capture a sense of the man's delusional thinking, so I distressed the surface of the paper with white ink splatter and text. (For paper, I prefer heavy vellum bristol, from Strathmore's 300 and 400 series.) Lastly, I cut into the paper with an X-Acto blade.

I SHOULD HAVE KNOWN SHE WAS TROUBLE, INK ON PAPER. ATTACK OF THE "B" MOVIE SHOW, SPACE GALLERY, SAN FRANCISCO, 2008.

This was created as part of a three-piece series paying homage to film noir, for an art show with a B-movie theme. I employed some light wash in the man's suit and the background and some splatter in the woman's skirt, but this is mostly straight-up black and white. Unlike the previous two pieces, the black here is really a background element, and it's the white that carries the visual power in the piece.

THE CABINET OF DR. CALIGARI, INK ON PAPER. PROMOTIONAL PIECE.

Together, the previous illustration and this one underscore the flexibility of black and white. In the last illustration, I intended to approximate the feel of film noir. I felt that I succeeded in capturing that quality while still making an image that was organic and unique to me. Here, I wanted to do a piece based on one of my favorite films, the 1920 silent horror film *The Cabinet of Dr. Caligari.* It's one of the most influential Expressionist works ever made. So, using the same medium and tools—black ink, crow quill pen, globe nib, brush—I was able to create this piece using Expressionist elements from the film. This piece and the previous one both employ the same basic techniques—splatter, fine and thick pen lines, heavy blacks applied with a brush—but they create entirely different moods.

MYSTIC, INK ON PAPER. SÉANCE: MYSTERY, SUPERSTITION & THE OCCULT, JULIAN ALLEN GALLERY, MARYLAND INSTITUTE COLLEGE OF ART, 2014.

This was for a group show based on a séance theme. Unlike some of the other pieces, this one is very graphic and flat. The blacks and whites are stark, and there is no wash or splatter. The gray areas in this image are actually made up of thin lines bunched together to create the appearance of gray. I wanted this to feel mysterious and bold—like a poster. It also had to evoke the 1920s, when séances were all the rage.

ILLUSTRATION'S UNSUNG HERO

Achieving Clarity through Composition

MEDIUMS ARE THE SEXY STUFF. Everybody is hip to color and line—those are the stars in just about every job. But what of illustration's unsung hero? I'm talking about composition. It deserves some love, too. It goes hand in hand with concept and really helps drive the story.

When I was studying at the Pratt Institute in New York City, I learned an old design theory that I think serves an illustrator well. It says that a good composition has a dominant, a sub-dominant, and a subordinate image or area. The piece opposite shows what I'm talking about. In this illustration, you can see that the puppet is the dominant element, the background (divided into two parts) is sub-dominant, and the green characters on the panel are subordinate. The elements combine to tell the story. But if the balance were out of whack—if, for example, the panel were dominant—the story might be read very differently.

Composition can make or break an illustration. The energy that you create as an illustrator relies heavily on how the elements in your images are arranged. A symmetrical piece is static. It might be boring or it might be calming. It might be so balanced that it feels banal, or it might feel tense, as if portending some unseen horror. By contrast, a composition with a strong diagonal moves. It feels zippy, pulling the eye around the image.

SCHOOL BOARD, ACRYLIC AND INK ON PAPER. PUBLISHED IN *NEW TIMES LA.*

The composition you choose should depend on what you're trying to say in the piece. When you're composing, I'd suggest you keep the word *clarity* in mind. In arranging your composition's elements, clarify them and their importance to the story. Think of it like this: Suppose you ran into a friend on the street and she excitedly exclaimed, "And walking I it home passed that your fire and was when house I your noticed on and was!" You'd wonder if she was having a fit. By the time you rearranged the words and realized that she was saying, "I was walking home and I passed your house and noticed that it was on fire," your place would be a smoldering pile of ashes. The point is that, while the words were all there, the order wasn't right, and without the right order, you don't have clarity. An illustration is a visual story, and composition allows you to shape all the elements in an ordered way that creates clarity and tells the viewer the story.

In the piece ABOVE, the dynamic is very simple. The dominant element is the woman—1947 murder victim Elizabeth Short, known as the Black Dahlia. The dahlias floating above her are sub-dominant, and the background is subordinate. My intention was to keep the focus on her, using the flowers for both informative and decorative purposes. The dark negative space that surrounds her supports the piece and creates a calm yet sinister void. To give the flowers greater importance

ELIZABETH SHORT 5, ACRYLIC ON CANVAS BOARD. PROMOTIONAL PIECE.

than the woman would change the order and thus alter the story the piece is telling.

All the rules and theories of art and illustration exist for good reason. They're tried and true and for centuries have served visual storytellers well. On the other hand, rules were made to be broken, and if you have a good reason to go rogue and ignore them, by all means do so. Just be sure that the internal logic works and that the piece will make sense to the viewer.

You may have noticed that I like to put borders around a lot of my work on paper. They aren't usually

A

B

C

necessary in my paintings on canvas board, because I tape off the area in which I paint and use the color to define the space (although I do occasionally paint borders for effect). Sometimes my borders are hard and clean; at other times they're loose and sloppy. But I like borders for the dynamic they help create.

Borders contain the image and help activate the negative space. That's right, I said *negative space.* That's all the stuff that *isn't,* if you catch my drift. In a photograph of a man standing against a blank wall, the man is the positive space and the wall is the negative space. Believe it or not, there are people who think negative space is not as important as positive space, but you and I know better. Without negative space, you don't have a picture.

The border corrals all that negative space and makes it part of the piece. By giving it definition, you give it shape, and that shape helps define the positive space. Let's take another look at my illustration *White Christian Rapper,* ABOVE, which you saw in chapter 6. The

original version (A) did not have a border, and he actually works pretty well as a silhouette. But look at him with a border (B). You may or may not prefer the piece this way, but look how much more powerful the character appears once the space has been defined. He's practically bursting out of that box. Also, the area outside the character—the negative space—has been defined. You can see that even better when the negative space is filled with a color (C). By using a border, I've added an element that was missing in the original piece—the space he occupies—by defining the space that he doesn't occupy.

If you leave the negative space undefined, you're only telling half the story. In the case of my white Christian rapper, even the tight cropping of the border seems to say something about the character's demeanor: He seems angry, ready to burst out of the space. Or maybe he's just bigger than life—too big to be contained by the space. These are the types of choices that can support or undercut a concept.

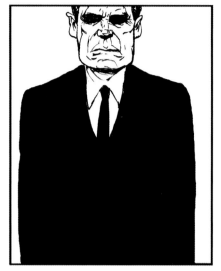
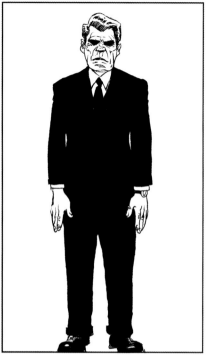
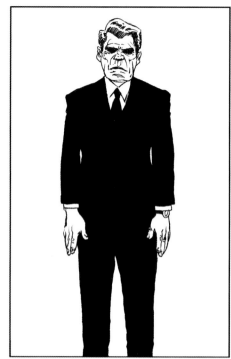

CROPPING THE COMPOSITION

When setting up a composition, try not to crop people's heads or bodies at weird places for no reason. It makes the viewer uncomfortable, drawing attention away from the message of the piece. You can't communicate well if your image is getting in the way of the story.

Let's look at a few badly cropped images of our friend Otto from the sidebar ON THE PREVIOUS SPREAD. The image ABOVE LEFT is a perfect example of the chopped-off head. The one ABOVE CENTER has the guy standing on the border. Why would you do this? It draws attention to the edge of the piece and takes the character out of his reality by nearly dropping him out of the illustration completely. Then there's the one ABOVE RIGHT—the ankle crop. Ouch!

Look how awkward this guy is. Of course, a crop like this could be used for effect if your story and logic matched. This is a horrible place to crop this character *unless,* for example, the illustration were for a story about a runner who lost his feet in the war and came back to the United States having to relearn how to walk. In that case, by cutting the guy off at his ankles, you'd be using a visually uncomfortable crop to make a point that's relevant to the story. Like I said, breaking the rules for a reason is fine.

Here's another image OPPOSITE for that story about the teenagers and their dead baby that I talked about in chapter 4. The character in the suit represents the government agency that was supposed to keep an eye

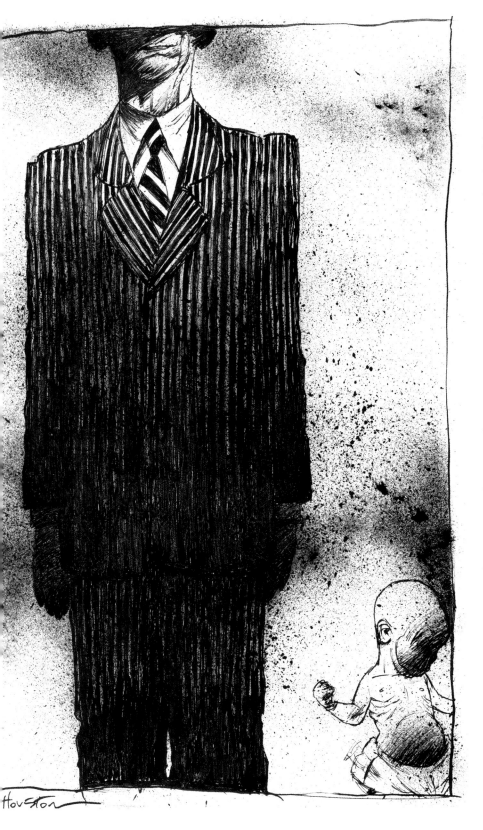

on the young family. I chose to cut him at mid-face—an uncomfortable crop—for a number of reasons. First, I wanted all the characters in this series of illustrations to seem out of place and awkward. Second, I didn't want to illustrate specific people; I hid their faces so viewers would have to focus on their clothes and body language—symbols of the segments of society they represent. Last, I wanted the baby to dominate the frame, even though he's so small. These were calculated choices that turned conventional compositional rules on their heads for a desired effect. But only by knowing the rules can you truly know how to subvert them. Just be sure that you make a *decision* to compose like this rather than having it happen because you weren't thinking about it.

GOVERNMENT WITH DEAD BABY, INK ON PAPER. PUBLISHED IN THE WASHINGTON CITY PAPER.

DIAGRAMING COMPOSITIONS

Every detail you include in an illustration is fair game for analysis by the viewer. You have to be in control, so be sure that you're saying what you mean to say. Diagraming a composition can help, so let's look at a few examples of completed illustrations and then diagram them.

The illustration RIGHT depicts two Dallas politicians who, as you can probably guess, were not popular with the writer of the article. Not only does the border contain the characters and keep them in the middle of the image, it makes the crow on the guy's head look large (because it doesn't fit within the frame). Look at the pointing fingers. If the border weren't there, the fingers would just dissipate into the ether and lose their accusatory power.

The diagram shows the basic composition. The crosses create visual energy as they thrust in opposite directions. The crossbars, particularly on the front cross, create a secondary thrust, defining a triangular area containing the image's most vital information. The U shape of fingers encircling the bottom of the image reinforces the center by pushing the eye back to the middle.

I did the piece OPPOSITE for a show at Washington, D.C.'s 9:30 Club. The rock band KISS had just reunited for a very lucrative tour, and the concept was to show a fat

BEST AND WORST CRU-CIFIXION, INK ON PAPER. PUBLISHED IN THE *DALLAS OBSERVER*.

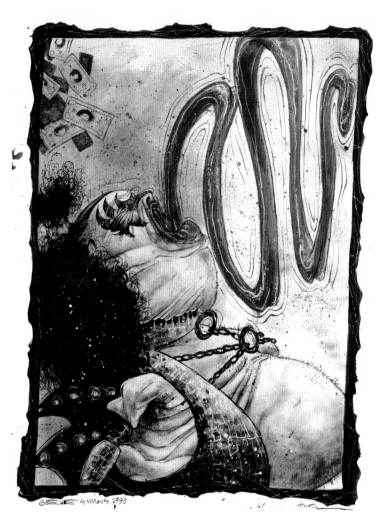

Gene Simmons spitting blood and wagging his tongue for cash. (Listen, I like KISS as much as the next guy, but the thought of seeing a middle-aged Gene Simmons squeezed into Lycra was alarming.) The dynamic of the piece is created by the two diagonals intersecting at Simmons's mouth. The eye can go up or down the figure, but when it hits that junction, it follows the tongue to the border and bounces back in. Simmons's gut seems bigger because it protrudes beyond the border. When composing an image, it's helpful to think of it as simple geometric shapes. From the diagram, it's easy to see the angled thrusts—up to the left and then to the upper right. You can also see roughly how much negative space there is in this illustration and how it helps define the positive space.

It's clear that the arm jutting across the page creates the main thrust in the piece ON THE NEXT PAGE. It also conveys the concept. No border was needed here because the colors cover the image from top to bottom and side to side, defining the edges. The background is integral in telling this illustration's story: An addict exists in the real world of pain and sorrow, as indicated by the green part of the background, but by injecting himself with a drug, he's entering a world of pleasure, indicated by the brighter red section of the background, which is literally slicing into the addict's arm and crowding out reality by encroaching on the green space. The black on the

GENE SIMMONS, ACRYLIC AND INK ON PAPER. FOR A SHOW OF ROCK 'N' ROLL STARS AT THE 9:30 CLUB, WASHINGTON, D.C.

extreme right of the piece represents the darker reality that lurks on the other side of the high. As the diagram shows, the thrust here is short and sweet. The division of the background plays against the arm, which creates the tension in the image. Color and composition combine to reinforce a fairly simple concept.

A fairly symmetrical composition can also be powerful. While the illustration OPPOSITE LEFT is fairly static, there's actually a lot happening to keep the eye in the general vicinity of the character's face—the punch line of the piece. By positioning the character dead center and placing his face at roughly the midway point, I'm basically trapping the viewer's eye there, commanding it to study the face.

In the diagram, X marks the stopping spot, thanks to the corner framing, the placement on the diagonal, and the curve of the umbrella handle, which directs the eye back toward the center. Because most people looking at this piece read it from left to right, the umbrella acts as a wall that stops the eye and then boomerangs it back to the face.

The piece OPPOSITE RIGHT was an illustration for a story about a guy getting pinched on a domestic abuse charge while staying at a hotel with his girlfriend. What the police don't know is that there's a lot more to this man than meets the eye. The art director and I agreed

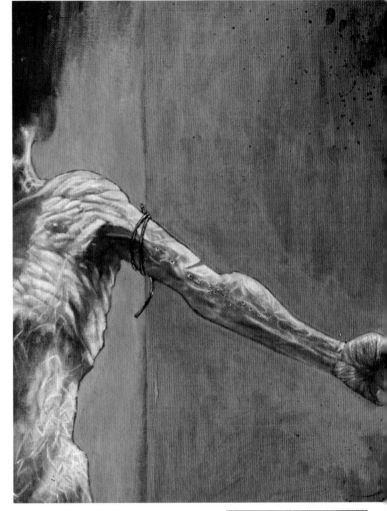

that the piece should be noirish in concept and tone. I decided to tilt the whole image to the left to create drama and confusion. The drama comes from the fact that anything can go sideways in a situation like this. The confusion is that of the character, who just

ADDICT, ACRYLIC ON CANVAS BOARD. PROMOTIONAL PIECE.

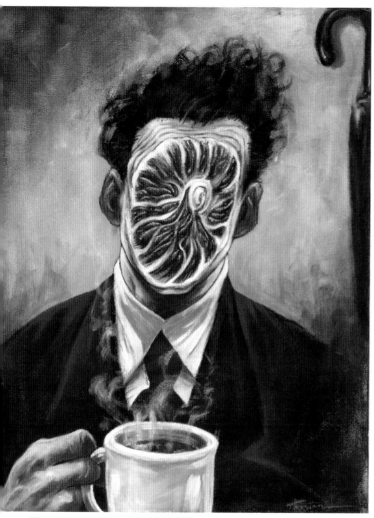

BUSTED, INK ON PAPER. PUBLISHED IN THE *RIVERFRONT TIMES.*

MEATFACE, ACRYLIC ON CANVAS BOARD. PROMOTIONAL PIECE.

woke up and doesn't yet realize what's happening. The dark shadows around the door frame the piece and focus the eye on the action.

In the diagram, I break the illustration down into the basic dark and light shapes. The main character juts slightly into the tilted doorway, creating a moment of instability that can be read as drama, confusion, or trepidation. The dark shadows around the top of the door frame it and push the eye back down into the doorway, which is where the information is.

At RIGHT is one of the interior pieces for that *Village Voice* cover story on New York's "taxi wars" that I showed you in chapter 6. Here, the cabbie is being followed by an NYC Transportation Department cop. A chase is about to ensue. It appears to be a pretty static composition. But is it? The rearview mirror and the steering wheel balance each other, while the figure angles up and to the right of the page, creating some tension. None of this would work if it weren't for the light reflected on the cabbie's face. That pulls the viewer's eye up and into the corner, emphasizing the image's intimacy and claustrophobia. True, the headlights in the back window offset the face, but those are in the background while the cabbie is in the foreground, so a spatial imbalance is created. (You should always consider all six "sides" of the image—not just the top, bottom, and left and right sides but also the foreground and background.) As I've said, I usually put a border around my acrylic-on-paper illustrations, but I didn't do that here because the piece is self-contained.

In the diagram, you can see how the diagonals create an X, crossing at the headlights. The cabbie's face and the headlights are like X's and O's in a tick-tack-toe game. The cabbie's face pulls the viewer from the front to the back of the image.

I'm a proponent of using repeating shapes in a composition to ring the important area and keep the viewer's eye from wandering off. The piece OPPOSITE is narrative, capturing a moment in

DRIVER, ACRYLIC ON PAPER. PUBLISHED IN THE *VILLAGE VOICE.*

a larger story. The central character is the Meatboy, who has just done something heroic to save his community. When I did this, I realized that the hats were the obvious element to repeat. While they differ in color and style, all are essentially circles, and when those circles are repeated to form a larger circular shape, they focus the eye on the Meatboy. The diagram shows how the hands of the revelers create a strong thrust, moving the viewer's eye up to the character. The repetition of circles and the circular dynamic keep the eye moving around without sliding off the page.

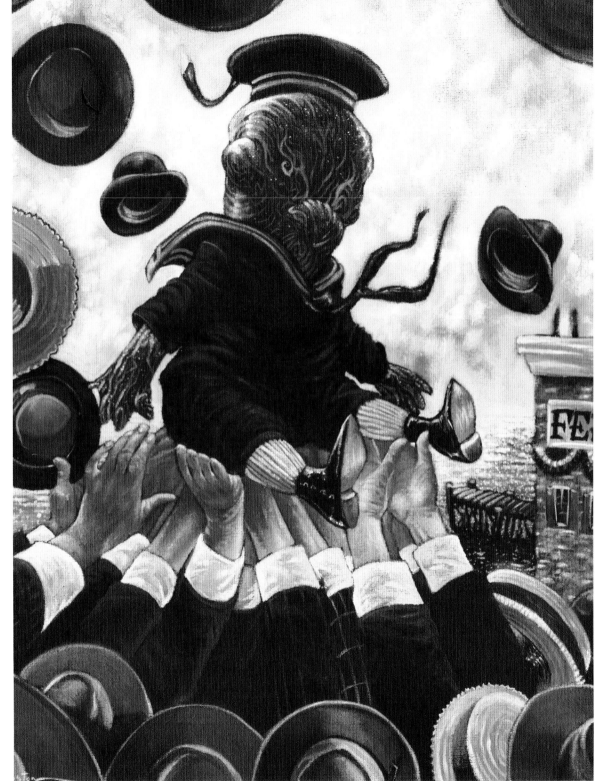

HUZZAH FOR THE MEATBOY,
ACRYLIC ON CANVAS BOARD.
PROMOTIONAL PIECE.

COMPOSING ILLUSTRATIONS WITH TEXT

Now I'll introduce one more element into the design mix—text. Often you'll find yourself doing an illustration that will ultimately include text. This is especially true when the piece is for a cover. It can be tricky to compose a nice, legible image when you have to leave space for a bunch of words. If it's a cover image, you'll probably need to consider the placement of the periodical's banner (i.e., its name) as well as one or more headlines giving information about the issue's contents. But movie posters and covers for CDs, video games, and books also usually feature some kind of name or logo. Let's look at a few examples.

At RIGHT is a cover I did for *Urban Tulsa*, for a story about Oklahoma's wacky Republican senator Jim Inhofe. I wasn't entirely sure what the tone for this should be. To me, the story seemed to be pretty damning, but the art director told me that they weren't "going after" the senator. Ultimately, this divergence didn't affect my concept, which has to do with Inhofe's being a pilot. The trick here was to fit a plane on the cover while still having space to devote to the senator's face (so readers could identify him easily) and leaving enough space in the top and bottom areas for the banner and other text.

As the diagram makes clear, the illustration is fairly horizontal even though the orientation of the page is vertical. This provides a lot of negative space that can be manipulated to create an imbalance. The slight downward tilt of the

INHOFE, ACRYLIC AND INK ON PAPER. PUBLISHED IN *URBAN TULSA*.

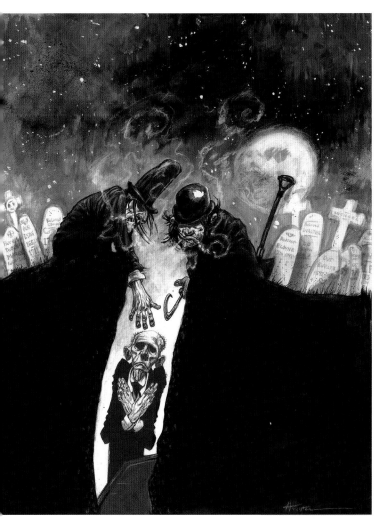

partly obscuring the oil derricks. (In the article, Inhofe was painted as a friend of the oil industry and a foe of the environmental movement—hence the tree "kills" on the side of his plane.) But because the oil derricks repeat, the viewer can still tell what they are. And because the top section is mostly black, no information is lost there, either.

Here's a tip: When you create an area that you know will be covered by text, make sure *not* to use a rainbow of colors. The text will have a color, too, so leave some for the art director to use.

I did the piece LEFT for a cover story about the history of grave robbing in Washington, D.C. I was particularly happy with the way this one turned out, because I had a lot of information to pack into it and because showing guys digging a hole doesn't necessarily work well in a vertically stacked space. But once I decided to do a cutaway of the hill within which the targeted grave rested, it was easy. The dark areas on either side of the hole allow plenty of room for text. The same is true for the sides and top (where the banner went). By using repeating imagery—tombstones, clouds—in those spots, I created areas that don't seem artificially empty. And because these elements repeat, covering some of them with text won't hamper the viewer's ability to understand what's going on.

plane creates a dynamic that works in conjunction with the negative space, and the popping color also helps pull in the eye. On the printed cover, the banner covers the top section, and there are smaller bits of text near the bottom,

GRAVE ROBBERS, ACRYLIC, INK, COLORED PENCIL, AND GRAPHITE ON PAPER. PUBLISHED IN THE *WASHINGTON CITY PAPER.*

It's a tricky proposition to illustrate people digging a hole and retrieving something from it. The action takes place underground, so it seems as if the best view might be from above the hole or from inside the hole looking up and out. Neither of those seemed workable when I considered the space needed for the banner, headline, and subheads. But by doing it as a cutaway, I was able to show the action both above and below ground and to anchor the composition at the bottom, allowing room for the banner at the top. The side areas served as text "boxes." The slight diagonal thrust, shown in the diagram, takes the eye up and to the right.

While it can be tough to see any part of your illustration "sullied" by text, it's going to happen on a cover. The piece RIGHT was for a Halloween issue of the *Anchorage Times*. I felt it was important to make the "weremoose" large and powerful, so that he would clearly dominate the space. This could have been a problem because it was inevitable that some text would also appear. But I knew the size and shape of the paper's banner. It's somewhat condensed, and the art director was willing to place it in a corner at the top (just over the antler on the left side of the image). As it turned out, I didn't lose anything vital to the image.

As the diagram makes clear, there's very little negative space here, and what little does exist is used

for text. Because the weremoose's head is lowered, the eye can move from his hands to his antlers—circling the face and keeping the eye from sliding off the page before taking it all in.

ALASKAN WEREMOOSE, ACRYLIC AND INK ON PAPER. PUBLISHED IN THE *ANCHORAGE TIMES*.

THE PAGE AS MOVIE SCREEN: "ALL ABOUT OTTO"

Sometimes it helps to think of the page or canvas as a movie screen. In the examples here, I'm drawing borders that create different "screens"—and that tell different stories. This is Otto.

Here, you see Otto in a close-up. Framed this way, Otto's image has a tremendous amount of power. Centered, he dominates the frame. (He could be made more powerful by closing the frame in tighter.)

Here's Otto seen from below. Otto holds the power in the composition because he dominates the frame.

Getting tired of seeing Otto in control? Okay, let's turn the tables on him. Ha ha! Look how small he is! This, for obvious reasons, is called the bird's-eye view. Now Otto doesn't look so tough. The negative space dominates the image, swallowing the figure and making him seem less threatening and more vulnerable. Puny human!

A symmetrical composition. Symmetry can be safe or it can seem like a limbo pregnant with unpleasant possibilities.

I call this the *horror crop.* When you see a character cropped like this, one of two things is about to happen: (1) He's about to get a fake scare—a cat jumps on him. Or (2) the killer is hiding somewhere just beyond the right edge of the frame and will suddenly reach out and brutally kill him with a gardening implement.

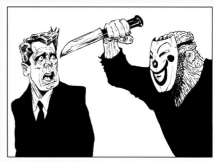

See what I mean?

ILLUSTRATE A BOOK COVER

Ready for your next assignment? How about a cover for Harper Lee's classic novel *To Kill a Mockingbird*? The reason I ask you to illustrate this particular book is that many people have read it, so I'm guessing maybe you have, too. But, if you haven't read it, go ahead and read it now. As a professional illustrator, you'll be required to be familiar with the subject matter you're illustrating, so this will be good practice. Also, because this is a book that has been reprinted over and over for decades, its cover has been illustrated repeatedly. That means you can consider how the story has been depicted in the past while challenging yourself not to copy what's already been done.

Once you've read the book, think about what kind of image would best summarize or communicate the flavor of the book. This image can be narrative or conceptual—whatever you think works best.

Before you begin illustrating, you've got to know some "specs"—the specifications for the job. The first of these is format: What are the cover's dimensions? For this assignment, let's say the cover will be 6 inches wide by 9 inches high. It's cool if you make your original art larger than that. (But don't make it smaller. Work almost always looks better when it's scaled down rather than blown up.) Make sure that your original work is proportional to the assigned size. The art director won't be able to use your illustration if it doesn't fit the job's proportions.

The piece will be for the front cover alone. (It won't wrap around the cover.) It'll be full color, so be thoughtful about your color choices and what they say about the story, its tone, or its setting. Remember that there will be text on the cover—the book's title and the author's name. You are not required to include the text in the actual art, but compose the image so that the text will fit comfortably without distracting from or crowding out the image. Unlike magazines and newspapers, most book covers don't have a fixed banner or headlines, so you have much more flexibility when designing for the incorporation of text.

Do this illustration in whatever medium you feel most comfortable using—traditional or digital. Once you've completed the piece, you may want to try another book cover following the same directions but perhaps in a medium with which you're not so comfortable. That will give you a good opportunity to evolve stylistically.

Here's the logic for this assignment: It's a classic, real world–type illustration job. As evidenced by the very tome you're holding at this second, they'll let anybody write a book, so there are a bunch of them on the market and they all need covers.

This particular assignment is part of the final in my Sophomore Illustration class. To see how one student solved the assignment, look at the image OPPOSITE.

SARA JABBARI, *TO KILL A MOCKINGBIRD* COVER, DIGITAL IMAGE. CLASS ASSIGNMENT.

Sara Jabbari is a terrific graphic designer who wisely used her design skills when creating this illustration. The dead bird is quickly recognizable; less obvious, yet equally important, are the colors, texture, and doilies that Sara chose to help establish the setting for the story. Even the font is carefully chosen to put the viewer in the environment. Taken as a whole, this is a beautiful example of a spare, thoughtful, well-crafted illustration grounded in great design. I show you this only to give you an idea of the route one artist took. It should inspire you to find your own solution.

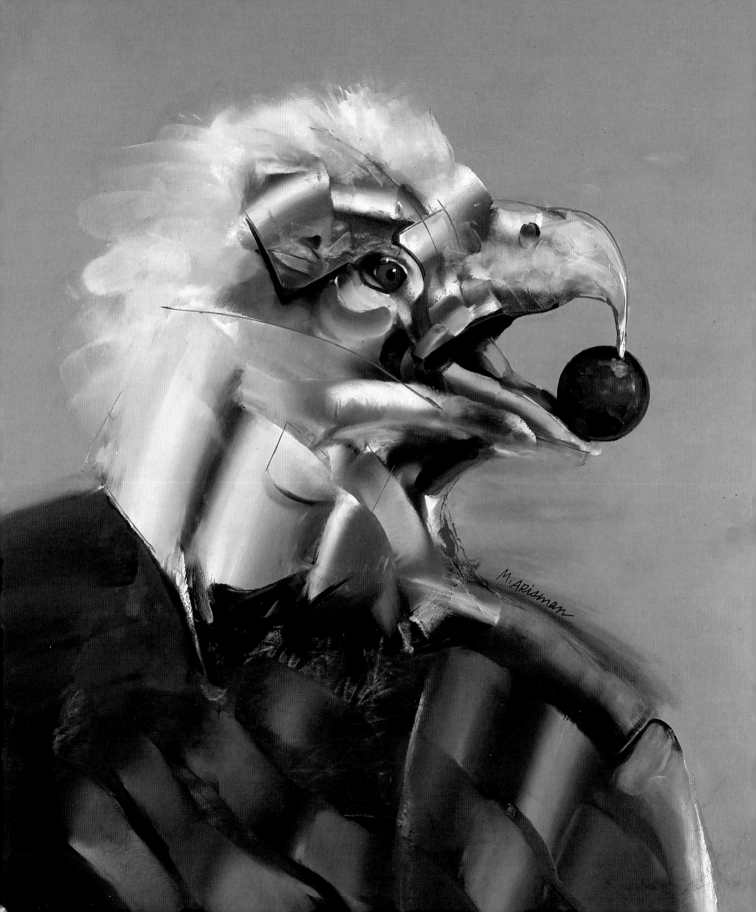

YOU'VE GOT TO HAVE STYLE

Making Stylistic Choices

NOW LET'S TALK ABOUT STYLE. Every illustration has a style—the overall look of the piece. And every illustrator has a style, and illustrators' styles can vary considerably.

To get an idea of how wide that variation can be, compare the illustrations of mine that you've seen in this book with the piece opposite, by modern master Marshall Arisman, which appeared in the *American Illustration Annual* for 1982. Arisman has a unique ability to create textures that compete with one another while still somehow working in conjunction. In this piece, he painted rough, wild feathers and then threw in stripes that appear almost metallic. The effect makes me feel as if someone has torn away one layer of the image to reveal another—that within this eagle there's another, frightening, robotic eagle bursting through. It's an incredible feat. Whenever I see an Arisman illustration, the word that always leaps to my mind is *power*. His work is raw, emotional, pure muscle.

Whether you know it or not, you, too, have a style. It may be underdeveloped at this point, but you've got one. Every illustrator starts off with a style that is unique to him or her. It reflects his or her tastes, worldview, influences, and talent. When you start out you'll probably feel compelled to create work in the manner you're accustomed to rather than thinking about what might be right for the piece.

MARSHALL ARISMAN, ILLUSTRATION FOR *AMERICAN ILLUSTRATION ANNUAL, 1982,* OIL ON RAG BOARD. COURTESY OF THE ARTIST.

Of course, this may not be an issue at first, since the art directors who hire you will probably choose you because of the style they see in your portfolio. But let's say that you've progressed in your career and want to tackle a wider variety of topics. At some point, you'll need to start thinking about what style is best for the subject matter. Marrying the look of the piece with the topic is important if you want to communicate the idea in the best possible way. Of all the words in this book, none are truer than these: *A successful illustration is the perfect combination of style and substance.* If that balance is off, the illustration suffers.

There are different schools of thought on this, but I think professional illustration is about piling up jobs. The more jobs you can get, the more money you can make. Ka-ching! So it makes sense to me to develop multiple styles that will allow you to be considered for many different assignments. There are countless ways to solve an illustration problem, but if you don't have anything in your portfolio to indicate that you can offer stylistic solutions for a variety of subjects, art directors

My style can get a little messy! Neatness is not necessarily a virtue!

BRIAN SANDERS, *THE OLD BILLINGSGATE MARKET FISH MARKET LONDON,* 1961, MIXED MEDIA. COURTESY OF THE ARTIST.

won't call you for jobs they think are outside the realm of your capabilities. So why not increase the odds of getting jobs by developing multiple styles that can be used for multiple topics?

How do you develop a variety of styles? Look at the work of other artists—not just illustrators but painters,

ALEX FINE, *STEVEN TYLER,* INK ON PAPER, DIGITAL. PUBLISHED IN THE *GRANTLAND QUARTERLY.*

In teaching illustration, my goal is not to *change* students when challenging them to stretch stylistically. Rather, it's to help them evolve—to help them push out from their center and grow. They should leave the class as a much bigger version of who they were when they started. I want them to build— conceptually, technically, and stylistically— on what they had when they started.

I showed you this Brian Sanders illustration OPPOSITE at the very beginning of the book, but I think it deserves another look here. Besides, we didn't discuss the way it was created, and that's particularly germane to this chapter because Sanders's style in this piece is clearly influenced by the materials he used. Looking at it is like watching a style being born. In the words of Sanders himself, "This image was made before the arrival of acrylic paints in Great Britain." He says it was "executed with charcoal pencil on canvas paper, coloured inks mixed with soap, and overpainted with gouache." Experimentation with mediums can breathe life into your own style.

The Alex Fine piece LEFT features the lovely Steven Tyler, the lead singer of the rock band Aerosmith. Here,

photographers, sculptors, and filmmakers, as well. Try out different mediums. Challenge yourself to handle topics that you normally wouldn't gravitate toward and think about what the image for a particular story *should* look like instead of how you would usually make it look.

Fine employs a smooth, clean, precise line, and the use of one flat color gives the piece a graphic quality. The size and placement of the subject makes him dominate the space, and the arm leading to the microphone pulls the eye right into Tyler's huge mouth. If you stare directly at it, you can hear the shrieking!

Let's finish with another illustration by Warren Linn, OPPOSITE, which shows the artist playing with stylization, color, and texture. The combination of paint and collage (including metallic objects) is fun and fearless. This once again goes to show that an illustration can be created in any medium provided it communicates the concept. Clients will put limitations on an illustrator—almost always out of necessity—but an illustrator who's still developing his or her style(s) should keep an open mind and not be tethered to the expected or mundane.

And while we're still on the subject of style, let me just add this. If, when you're asked what your style is, you reply "manga," or "anime," or *Adventure Time,*" then *you have no style.* Yes, I know that manga and anime are both genres, and, of course, it's fine to work in those genres. But if the work you're producing looks like work that preexists you by decades, or if your work is highly consistent with some popular animated kids' show that you didn't create, these styles are *not* yours. They belong to someone else, and trafficking in them doesn't change that fact. Don't be a style thief.

WARREN LINN, INTERIOR ART FOR THE CD *THUMBSCREW* (CUNEIFORM RECORDS, 2014), MIXED MEDIA. SELECTED FOR *AMERICAN ILLUSTRATION 33.*

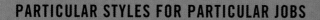

PARTICULAR STYLES FOR PARTICULAR JOBS

I'm able to work in a variety of styles and mediums—all organic to me. I get bored easily, and I like to jump around between topics and tones. This allows me to do lots of different jobs for lots of different clients. Anyway, here I'm going to show you a bunch of illustrations and say a little bit about why I chose a particular style for a particular job.

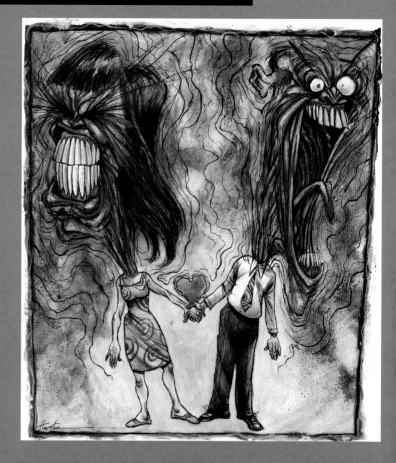

ABOVE LEFT: *JITTERS*, INK ON PAPER. PUBLISHED IN THE *CITY PAPER* (BALTIMORE).

For a story about a writer's coffee addiction, I did this. It's similar to the next illustration—wavy border, hairy line, splatter. I chose this style because I thought it best captured a caffeine jones—the jumpiness that too much caffeine can cause.

ABOVE RIGHT: *UNHAPPY MARRIAGE*, ACRYLIC, INK, AND MARKER ON PAPER. PUBLISHED IN THE *SAN DIEGO UNION-TRIBUNE*.

This was for an article about unhappy marriages. I chose to use this style—cartoonish and exaggerated, with jittery lines and hot colors—to capture the quality of the anger and bitterness these characters are experiencing.

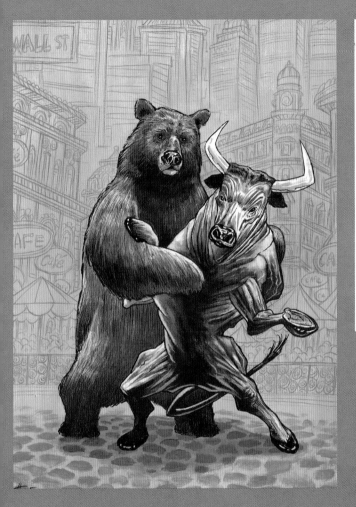

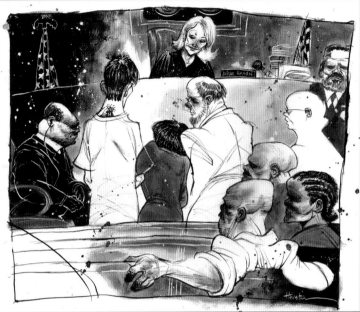

DRUG COURT, COLORED AND BLACK INKS ON PAPER. PUBLISHED IN THE *BALTIMORE SUN*.

This actually is a piece of reportage. I sat in a courtroom all day and illustrated the proceedings as a time lapse to give the viewer the feeling of what a day in drug court is like. I chose this palette because the client wanted a color piece and I felt that these drab colors would capture the boredom of a day in court.

WALL STREET, ACRYLIC, INK, AND COLORED PENCIL ON PAPER. FOR AGORA FINANCIAL.

This one—a cover for a book on finance—is very different from the last two. The bull and bear represent the ups and downs of the stock market. The characters are depicted in what I would call a stylized realism. They're not quite cartoons (the light, shadow, dimension, color, and anatomy are mostly realistic), but they're behaving in a way that is inconsistent with reality. The highly stylized background is colored with a "money green" wash to drive home the point.

PORTFOLIO: THE RIGHT STYLE FOR THE JOB

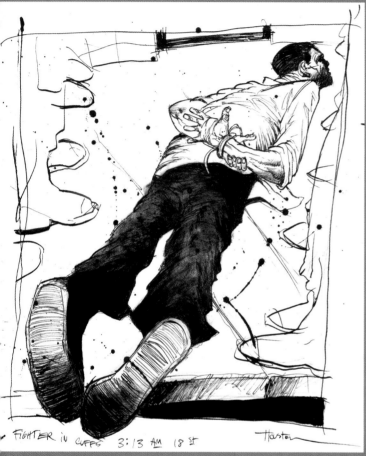

FIGHTER IN CUFFS 3:13 AM 18 St

SATURDAY NIGHT FIGHTS, INK ON PAPER. PUBLISHED IN THE *WASHINGTON CITY PAPER.*

Here's another piece of reportage. Immediate, on the spot, in your face. It was for a story about the chaos in the streets of Washington, D.C.'s Adams Morgan neighborhood on a Saturday night. I was on the scene with the writer and art director, hopping from a brawl, to an arrest, to a vomiting bridesmaid, capturing each image on my pad. I chose this pen-and-ink style thinking that the sloppiness would bring the viewer into the action.

CHARLIE CRIST FOR GOVERNOR, ACRYLIC AND INK ON PAPER. PUBLISHED IN THE *ORLANDO WEEKLY.*

This was a cover for a story about former Florida governor Charlie Crist's return to the state's political scene in 2014. At the art director's suggestion, I depicted Crist in a religious pose with religious trappings. To capture the story's satirical mood, I tried to approximate religious iconography while still keeping the piece light. I was allowed to hand-letter the paper's name, which I think enhances the stylistic choice.

THE CHILD CATCHER, ACRYLIC ON CANVAS BOARD. PROMOTIONAL PIECE.

CRYBABY DOCS, ACRYLIC ON CANVAS BOARD. PUBLISHED IN THE *HOUSTON PRESS.*

I wanted to reimagine the Child Catcher character from the 1968 film *Chitty Chitty Bang Bang,* who traumatized me when I was a kid. I wanted him to feel dimensional but not "real," so I opted for a stylized realism. Because he's a hunter, I made him look sharklike. I wanted the colorful elements of his costume and wagon to stand out against an otherwise cold environment, and I gave an expressionistic feel to the architecture in the background, to make the setting seem foreign and fairy tale-like.

This piece was a cover for a story about some doctors (one in particular) who didn't get their way in a ruling regarding their practice. The ensuing tantrum that they threw (name calling, yelling, etc.) was apparently a sight to behold. The client wanted a comical depiction of the doctors as spoiled children, so caricature seemed like a natural stylistic choice. The approach was similar to the Charlie Crist piece OPPO-SITE but the use of acrylic on canvas board, as opposed to acrylic and ink on paper, gives the image a different weight and feel from the breezier, lighter Crist piece.

PORTFOLIO: THE RIGHT STYLE FOR THE JOB

SANTA SANGRE, ACRYLIC ON CANVAS BOARD. PROMOTIONAL PIECE.

This was inspired by Alejandro Jodorowsky's 1989 film *Sante Sangre*. While I'm not a huge fan of the director, I found this film to be moving, disturbing, and elegant. I wanted to capture all those qualities, so I employed a look that's cleaner, softer, and more stylized than much of my other work.

CONSERVATIVES LOVE AYN RAND, ACRYLIC AND INK ON PAPER. PUBLISHED IN *INDY WEEK*.

This was for a story about the Tea Party's idolization of conservative philosopher Ayn Rand. The article was not flattering, so I chose caricature—possibly the least flattering style of all. The goal wasn't to make the characters—Rand herself and then–Republican congresswoman Michele Bachmann—look nightmarish. I just wanted the situation and concept to dictate the tone.

AMISH IN THE CITY, ACRYLIC AND INK ON PAPER. PUBLISHED IN THE *WASHINGTON CITY PAPER.*

For a story about a guy who grew up Amish in Washington, D.C., I wanted something that felt real but not photorealistic, so I went with a "designed" realism. I wanted the main figures to feel stiff and alien in their environment. I also wanted the kid to feel small, since he was especially vulnerable. The color wash helps separate the characters from the setting. The straight-on composition adds to the stilted, uncomfortable feeling.

BUSY COUPLE, ACRYLIC, INK, AND COLORED PENCIL ON PAPER.

I no longer remember what this piece was for—an ad for something. But I do recall that it was about multitasking. I've chosen to show it to you because its stylistic elements set it apart from the other pieces of mine you've seen. It's far friendlier. The colors are happy. The characters are cartoonish and simple. The goal was to tell the story engagingly but without being offensive.

DO A CD COVER

You've been reading a lot about concept, medium, and style, so let's see if you can bring all these things together to make another great illustration. Let's pretend you just got an email from a record company—assuming they'll still exist when you buy this book. The art director tells you the job is a CD cover for a band you really like. Score!

To do this assignment, you need a band. It can be a famous band or your own band or a band you just made up this very second. What's the band's name? What's the musical genre? What's the CD's title?

Consider the visual elements that will go into making this piece—style, color, medium, composition. How can you use these things to tell the viewer about the kind of music on the CD? If it's a bluegrass band, what kind of imagery would be appropriate? What colors would you use? How about if it's a punk band? Ska? Swing? Funk? What concept fits? How will you communicate information about the band and its music to the audience?

There are two things to keep in mind as you start to work on this piece. First, as with the book cover, text will probably be imposed on this illustration—the band's name and the CD's title. You don't have to create the text yourself; just remember to leave room for it. Also, remember that CDs are square. (This isn't a wraparound, just the

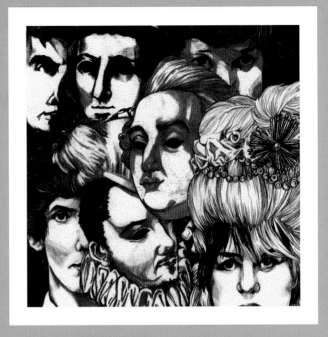

ANDREA MASTROENI, CD COVER FOR TALKING HEADS' "PSYCHO KILLER," INK ON PAPER, COLORIZED DIGITALLY. CLASS ASSIGNMENT.

front cover.) Square illustrations can be challenging to design, so really think about the composition.

ABOVE AND OPPOSITE are two examples of actual students' solutions. These are just to give you some feeling for the assignment. Don't copy! When creating her illustration, Andrea Mastroeni focused on the song lyric "Qu'est-ce que c'est" ("What is it?") and opted to show the band members in disguise to make them appear mysterious. In the other Talking Heads–inspired image, artist Alex Innocenti chose to take the river of the song's title and to add surreal elements—the woman and the large, ominous hands.

So… begin!

You've scored, baby!

ALEX INNOCENTI, CD COVER FOR TALKING HEADS' "TAKE ME TO THE RIVER," ACRYLIC, AIRBRUSH, AND COLORED PENCIL ON ILLUSTRATION BOARD. CLASS ASSIGNMENT.

I NEED AN ILLUSTRATOR

Getting the Job

I LOVE DEVIL DOGS. I don't know who invented them or for what evil purpose, but Devil Dogs are easily the *driest* dessert food ever made. They're delicious, but, man, they soak up every drop of fluid in your body like some kind of demonic hell sponge. So imagine an art director has just hired you to create an illustration for a humorous story about dessert foods. And let's say that the food you'll be illustrating is the mighty Devil Dog in all its fluid-sucking glory. Do you know why the art director called you? Because she can't shoot it! Even if the photo were spectacular, would it really tell the story? Could it really communicate to the viewer just how mouth-drying the Devil Dog experience can be? No way!

There are lots of occasions when art directors have to go to an illustrator, and chief among them is when the concept can't be photographed. But just because it can't be shot doesn't mean it can't be shown. Take my piece opposite, which the *Washington City Paper* commissioned for a story about a D.C. man who had burned down several houses. The *City Paper* had photos of the culprit, but the arsonist certainly hadn't been photographed in the act, so this illustration is preferable to a bland photo of a suspect in custody.

ARSONIST, ACRYLIC, INK, AND COLORED PENCIL ON PAPER. PUBLISHED IN THE *WASHINGTON CITY PAPER.*

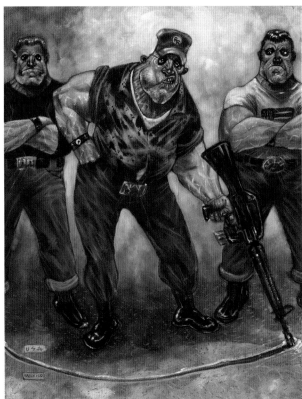

DRUG KILLING, INK ON PAPER. PUBLISHED IN THE *RIVERFRONT TIMES.*

RANCH RESCUE, ACRYLIC AND INK ON PAPER. PUBLISHED IN THE *HOUSTON PRESS.*

An illustrator can create an image from scratch to communicate a concept, and this may be true whether the subject is conceptual or narrative. For a story about a drug sale in a Detroit alley, it's a good bet that there are no photos documenting the event. And if the story takes place on a different planet, in a different dimension, or in the future, you're going to have a very hard time finding someone to photograph that. An

I said I want an *illustrator!*

illustrator is a visual storyteller whose boundaries are the limits of his or her imagination and technical skills. Let's take a look at some examples of what I'm talking about.

ABOVE LEFT is a narrative piece for a story about the murder of someone connected to a drug cartel. The events in the story were true but couldn't be photographed. The composition creates a frame that closes in on the doomed character. The hard diagonal creates drama and tension.

The piece ABOVE RIGHT was for a story about a Texas militia bent on protecting ranches on the U.S.–Mexican

GREG'S RULES FOR ILLUSTRATORS

Rule #3: Meet Your Deadline!

You heard me. *Get the job to the client on time!* Let's say you're doing a cover for *Time* magazine and *Time* goes to press on a given day at a given time. Now let's say that you don't have the piece ready. Your dog ate it or whatever. The point is, you don't have it. Do you think *Time* magazine is going to delay publication because of you? They'll find an alternate cover, the art director will get an earful from the person above her, you won't get paid, and you will *never* work for *Time* again. Stick a fork in yourself because you're done.

You'll find that there are deadlines and drop-dead deadlines. A drop dead is when a second, absolute deadline exists beyond the deadline initially given. Sometimes, art directors build a time cushion into a job—some breathing room in case something goes wrong. Missing a deadline is unforgivable, but, hey, life happens to the best of us. If you realize that you are encountering a problem that might prevent on-time delivery, it's not the worst thing in the world to contact the art director and see if an extension is possible. If so, the art director will give you the drop-dead date—and you'd better not miss that deadline!

If a problem does pop up, contact the art director immediately. Illustrators sometimes create big problems for themselves by avoiding an imagined confrontation with the art director rather than dealing with issues when they arise. Don't create a self-fulfilling prophecy of failure. Give yourself the best chance for success.

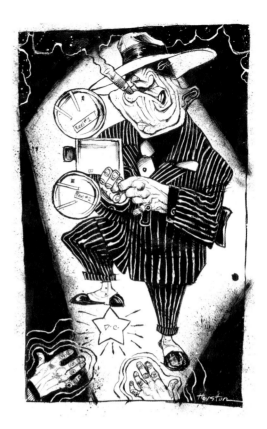

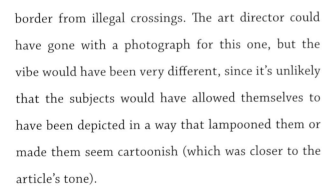

STUN BELTS, ACRYLIC AND INK ON PAPER. PUBLISHED IN *CLEVE-LAND SCENE.*

MUSCLING IN, INK AND WHITE INK ON PAPER. PUBLISHED IN THE *WASHINGTON CITY PAPER.*

border from illegal crossings. The art director could have gone with a photograph for this one, but the vibe would have been very different, since it's unlikely that the subjects would have allowed themselves to have been depicted in a way that lampooned them or made them seem cartoonish (which was closer to the article's tone).

ABOVE LEFT is a piece I did for a story about a company that made stun belts. I don't think the client was interested in asking a volunteer to be shocked for a cover image. Also, the exaggerated, cartoonish style gets the message across better than any photo would.

For a story about an "art cinema" theater chain moving into the D.C. area and pushing out independent art-movie houses, I did the piece ABOVE RIGHT. It works by anthropomorphizing the theater chain, casting it as a stereotypical 1920s gangster. For illustrators, the beauty of living in this age is that we have an extremely rich visual language to draw upon. I chose a gangster from the 1920s because I was confident that the audience would immediately get it. This visual shorthand allowed me to communicate the concept easily. Once the viewer identifies the character, the movie camera reels, and rifle stock, the whole thing comes together.

BOOK OF LISTS 1999, ACRYLIC, COLORED PENCIL, AND INK ON PAPER. PUBLISHED IN THE *BALTIMORE BUSINESS JOURNAL.*

Finally: Remember Y2K? At the stroke of midnight on January 1, 2000, the world was supposed to end because of a computer glitch. Everybody was worried, and illustrators were kept hopping trying to come up with images to convey the impending disaster. I took a slightly different approach. For the cover of a business annual,

ABOVE, I opted to feature a robot sporting the trappings of an old-fashioned businessman—suit, tie, briefcase—while also plugging into the new technology. A robotic future businessman—so much scarier than that Y2K nonsense! The robot is designed to look antiquated to keep the piece from being overly serious.

CREATE A POSTER

Picture this: You're sitting in your refrigerator box–size home studio when the phone rings. It's an art director and, boy, has she got a job for you. HBO is doing a documentary series on sex, and you've been chosen to do an illustration for it.

The series will consist of three specials, each with a theme:

- Marital Sex
- Fetishes
- Sexual/Gender Identity

Your assignment is to create a poster image for one of these topics. The poster's size is 17 by 11 inches, vertical orientation. If you choose to work in a traditional (non-digital) medium, be sure to make the art as big as or bigger than this. (Keep it proportional!) The only text will be the HBO logo and the date the show will air. (You may choose to include these elements, but you're not required to.) The poster should be full color.

I have two objectives in assigning you this job: First, I want you to work big. Working big can be frightening, but it really forces you to draw and paint details in a way working small doesn't. And if you work traditionally, it will give you a good idea about how the medium you choose works on a large surface. (It might be better or it might be worse.)

BOYA SUN, ILLUSTRATION FOR "MARITAL SEX" POSTER, DIGITAL IMAGE. CLASS ASSIGNMENT.

Second, the assignment challenges you to create an image for a provocative topic that can still can be shown in public—on walls and bus stands, in magazines and newspapers, and so on. That means that although your illustration might be a bit salacious, it can't be pornographic. There's no need to draw something that's going to make your mother cry if she sees it, but even so, the poster *is* for a series about sex. So what's appropriate?

I want to show you some solutions done by former students of mine. These are just to get your juices flowing, so to speak—don't let the examples determine your own take on this assignment.

Boya Sun chose to illustrate the poster for the "Marital Sex" episode, ABOVE. Her imagery is smart,

ERICA OSTROWSKI, ILLUSTRATION FOR "SEXUAL/GENDER IDENTITY" POSTER, GOUACHE ON WATERCOLOR PAPER. CLASS ASSIGNMENT.

CLARE DEZUTTI, ILLUSTRATION FOR "FETISHES" POSTER, DIGITAL IMAGE. CLASS ASSIGNMENT.

elegant, and clear. The whole thing is predicated on a kind of visual trickery—the raised finger is not the one you might expect, and the ring is really a condom. As a poster, it works great from a distance, because it's easy to misread the finger and condom as the things they aren't. It seems much more provocative than it really is. Perfect for a documentary of this kind!

Erica Ostrowski chose to illustrate a poster for the "Sexual/Gender Identity" episode, ABOVE LEFT. She cleverly mixes and matches parts of the characters' anatomy to create two beings whose genders are difficult if not impossible to identify. As in Boya's piece, the message is simple and to the point. Erica's use of playful colors keeps the image from being off-putting, and they also draw attention from a distance—perfect

for a poster. Finally, by making the characters' anatomy so doll-like, she's being pragmatic. It keeps the poster G-rated and gives the client something that can actually be posted in a public place.

ABOVE RIGHT is Clare DeZutti's illustration for the "Fetishes" episode poster. By mixing various garments and textures, she creates layers of options from which the fetishist can choose. It almost appears that the woman's hand is hovering over the garment she's thinking of grabbing. As Clare says of her work, "I used the diagonals to guide the eye through an overwhelming image to give it order."

Okay. You've seen what a few other artists have done. Now it's your turn!

FASHION! HAIR! CARS!

Styling and Research for Accuracy

NOW LET'S TALK ABOUT *STYLING*. (Not style. We already covered that.) On a film or photo shoot, there's generally a person known as a stylist. The stylist's job is to select and arrange props, to costume characters appropriately, and stuff like that. Well, when putting together an illustration, you yourself are the stylist. When you create the image, you are creating a world. You decide what the environment and its inhabitants look like—including the characters' costumes.

Have a look at my piece, called *Midas*, opposite. The concept was to take a character from legend and update him for the twentieth century. For Midas, I wanted a guy from the 1930s or 1940s. Even though his clothes are made of gold, they follow the basic styles of that era—a broad-brimmed fedora, a three-button jacket with wide lapels, a wide tie with a narrow knot, and a white shirt with a medium collar.

When you're doing an illustration, everything's got to be consistent, and it's got to conform to the internal logic of the piece. An otherwise great image can be broken open like a piñata if the internal logic doesn't work. Getting the period or look of the characters wrong is a surefire way to screw up your illustration. If it's set in 1947, it should look like

MIDAS, ACRYLIC ON CANVAS BOARD. PROMOTIONAL PIECE.

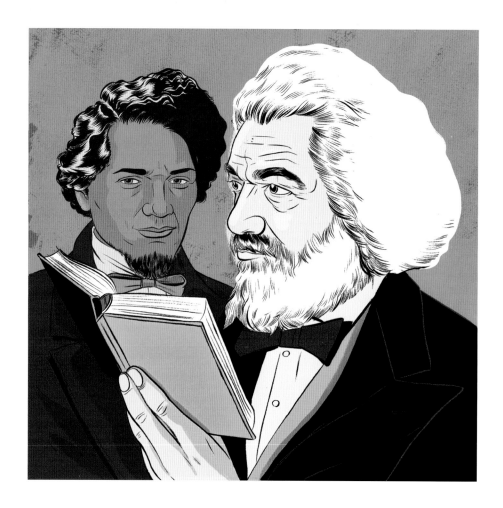

1947. If you don't know what 1947 looked like, you've got to do research. What did the people wear? How did they wear their hair? Their makeup? What did street signage look like? How about their cars? Did they have TVs? What about the wallpaper? You need to get all the details right. If

It's not just the style, it's the styling.

you only have to approximate the time or feel of an era, know enough about it to pull off the general vibe. If you need to be precise, then compile some resources that give you precise images from which to work.

How do you evoke a historical period but still keep your image fresh and modern? The beautiful image by Alex Fine ABOVE does just that. The clothes and hair in this double portrait of revered African-American leader Frederick Douglass are correct, but Fine's simple line technique makes the illustration look up to date.

ALEX FINE, *FREDERICK DOUGLASS,* INK ON PAPER, DIGITAL. PUBLISHED IN THE *CITY PAPER* (BALTIMORE).

correct

insane

MEN IN SUITS—
THE SUIT/SHIRT/TIE COMBO

Speaking of styling, let's get one thing straight: Men generally don't wear blouses with large, scoop-necked Peter Pan collars and flimsy ties under jackets with huge, triangular lapels that look like something out of *The Jetsons*. For some reason, the simple suit/shirt/tie combo tends to utterly baffle students. Surely you must each know somebody who wears, or has worn, a jacket and tie. Maybe you've worn them yourself.

Behold the two images above. If you think the one on the left looks right, congratulations! You are not insane. If you think the one on the right looks okay, stay away from sharp objects.

Even if you're creating an entirely original world, think logically. Do your characters' clothes make sense structurally? Are you thinking about how clothing and hairstyles inform your characters?

I'll let artist Patrick O'Brien tell you about his illustration ABOVE: "The USS *Constitution* was built in Boston in 1797. She earned her fame in the War of 1812, when she won three celebrated victories over the British, demonstrating that the new American navy could stand up to the greatest sea power in the world. She was nicknamed 'Old Ironsides' when British cannonballs were seen to bounce off her hard oak hull. This painting depicts a little-known event in her long career." In the Caribbean in 1799, the *Constitution* spotted a British frigate. It was peacetime then, and the British and American captains had dinner and decided to stage a race between the two great ships. The *Constitution* won. (I'll just add that if O'Brien got even one bit of rigging wrong on this, somebody would notice it and complain. So it has to be right.)

PATRICK O'BRIEN, *A FRIENDLY RACE: USS* CONSTITUTION *IN THE CARIBBEAN, 1799,* OIL ON CANVAS. COURTESY OF THE ARTIST.

Ted Papoulas, who did the piece ABOVE, is keen on authenticity. When preparing an illustration, Papoulas goes on site and uses photos and models. Want a Brooklyn street corner in the early 1990s? No problem—here it is! Coney Island in the 1950s? You got it. When an art director needs a piece in which the period elements have to be precise and correct, Papoulas's talent for capturing detail gets him the call.

TED PAPOULAS, *FEBRUARY PHARMACY,* ACRYLIC ON CANVAS BOARD. PROMOTIONAL PIECE.

I work exclusively out of my head unless I'm required to illustrate something very specific—President Gerald Ford, a Ford Focus automobile, a Colt .45 pistol, or a bottle of Colt 45 malt liquor. In general, I try to be diligent about looking at the world around me and mentally cataloguing what I see. I go to museums, look at old photographs and illustrations, watch old movies and TV shows—whatever it takes to broaden my visual language. This serves me well when I'm just going for the feel of a period or place without having to be exact. But if I'm not sure or I have to be exact, I look stuff up. I do the necessary research.

ABOVE LEFT: *PÜ IN THE LOU*, INK AND ACRYLIC ON PAPER. PUBLISHED IN THE *RIVERFRONT TIMES*.

Every year, there's a big music festival in St. Louis called the LouFest. This image isn't of it—it's about its underground doppelgänger, which organizers dubbed "Pü in the Lou." Note the mohawks, piercings, Doc Martens, torn jeans, ear gauges, wristbands, tank tops, dark-framed glasses, soul patches, porkpie fedoras, and the beer-soaked stage.

ABOVE: COVER FOR "BEST AND WORST OF 2013" ISSUE OF THE *DALLAS OBSERVER*, ACRYLIC AND INK ON PAPER.

This was a cover piece for a year-end best-and-worst issue. We decided on a zombie cabbie and some roughed-up pedestrians. It's easy to make a character look like a zombie, but a *cabbie* zombie? A slouchy applejack cap, a work shirt, and a bomber jacket should do the trick. And don't forget the pencil behind the ear!

MEATBOY AND HIS FAMILY, ACRYLIC ON CANVAS BOARD. PROMO-
TIONAL PIECE.

I am fascinated by old portrait photography. The amount of
time the subject had to stand still seems unfathomably long,
given today's super-fast shutter speeds. I love how weirdly
stiff and uncomfortable the people in the photos appear.
Influenced by those old portraits, I made this portrait of a hus-
band and wife and their son—who's made entirely of meat.
I approximated and exaggerated the clothes and anatomy to
further stress the formality and awkwardness. So I made up
a little story about a couple so desperate for a child that they
sculpted one out of scraps of meat and dressed him in fine
clothes. Did he come to life through the magic of their desire?
Or is he just an inanimate hunk of meat that they insist is a
sentient being? In my mind, he's like Arnold Ziffel from TV's
Green Acres. Arnold was a pig, but his owners, the Ziffels,
treated him like a human boy—as did all the inhabitants of
Hooterville. Only Oliver Douglas saw him as a pig. So when it
comes to the Meatboy, you can be a Ziffel or a Douglas.

LOOMING FARMER OF IMPENDING DEATH, ACRYLIC ON CANVAS
BOARD. PROMOTIONAL PIECE.

I made this piece because I liked the concept of illustrating a
perfectly ordinary farmer and giving the image a lurid, stupid
title. I wanted the character to look normal—overalls, a straw
hat, a striped shirt, and canvas work gloves—to contrast with
the hyperbole of the name. The location is a wheat field in
front of his home. I also gave him a tattoo—not decorative
but informative, like a 1950s Marine might have had.

WAIL, ACRYLIC ON CANVAS BOARD. PROMOTIONAL PIECES.

These paintings are from a six-piece series based on the 1956 song "Jump, Jive, and Wail," by Louis Prima. (The male half of *Jump* appears on page 68.) All the pieces are about swing dancing, and I set them in swing's heyday—the late 1930s to early 1950s. But I didn't want to convey a specific year or decade, so I designed outfits that captured elements of clothing style during that twenty-year span. For the guy here, that meant a short, shiny tie; a broad-shouldered suit, pleated pants, a white shirt, and greasy, shiny hair. I entirely made up the girl's outfit, but I tried to capture the quality of women's clothes of the time with the playful bee skirt. Her hairstyle evokes styles of later 1940s into the early 1950s.

WHERE'S VASQUEZ? INK ON PAPER. ATTACK OF THE "B" MOVIE SHOW, SPACE GALLERY, SAN FRANCISCO, 2008.

For a B movie–themed show, I created this entirely in my head, with a nod to the noir films of the 1940s and 1950s. The guy wears high-waisted, baggy pants with a skinny belt and a tight "wifebeater" undershirt. The gal wears a shiny negligee, a robe that's conveniently slipping off her shoulders, and seamed stockings. Of course, the guy gets a super-pomaded hairdo; the woman's hairstyle is a variation on the peekaboo look made famous by 1940s actress Veronica Lake.

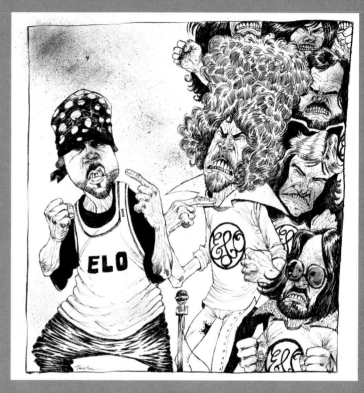

ELO VS. ELO, INK ON PAPER. PUBLISHED IN THE *WASHINGTON CITY PAPER.*

There was apparently a rapper named ELO. Everyone appreciated him—*except* the 1970s supergroup, ELO (a.k.a. the Electric Light Orchestra). Apparently, they didn't love his using "their" name. I did use references for the faces—who knows what any of these guys look like?—but the juxtaposition of the rapper of the 2000s with the insane hair and sartorial splendor of the 1970s is what made this piece work. Baggy pants versus numbingly tight jeans! Handkerchief headwear versus massive flyaway collars! There's no contest!

1970S ACTION PIMP, SHARPIE ON PAPER, COLORIZED DIGITALLY. PROMOTIONAL PIECE.

1970S ACTION THUG, SHARPIE ON PAPER, COLORIZED DIGITALLY. PROMOTIONAL PIECE.

This was part of a series on 1970s TV tropes. Who dressed better than the good people of that kaleidoscopic decade? And, more specifically, who dressed better than the TV pimp? Mind-bogglingly broad hats! Coats made from the fur of mysterious fuzzy white animals! Plaids in retina-burning color combinations! The widest, silkiest ties and even wider bell bottoms! Huge collars! Ruffled cuffs! Mile-high platform shoes! Giant hair, goggle sunglasses, a walking stick! (Yes, a walking stick!) In this illustration, the clothes make the man.

Here's another illustration from the '70s series. While this character inhabits the same universe as the previous one, notice the difference in fashion. This guy isn't as evolved. Though it's got a 1970s cut, his suit is plain. The stingy-brimmed hat, wide tie, flared pants, high-ish boot heels, and wide lapels are nosing into the decade, but he hasn't really made the leap from the 1960s. Even his greasy hair is still styled as it might have been in 1965. He's a follower, not a trendsetter. As gang muscle, his job is to blend in with the background, not stand out in a crowd. See what I mean about clothes informing the character?

1970S ACTION P.I., SHARPIE ON PAPER, COLORIZED DIGITALLY.
PROMOTIONAL PIECE.

One more: the P.I. There are basically two types of 1970s
private investigators: the Jim Rockford type—a guy who isn't
rich, stylish, or flashy and who lives in a trailer and gets
stiffed on his fees—and the glitzy, flashy, gimmicky P.I. who
always gets the girl. This guy belongs to the latter category.
The Burt Reynolds mustache, swinging sideburns, open poly-
ester shirt! Tight sport coat with visible stitching! Ridiculous-
ly tight bell bottoms! Pointy boots! He's a two-fisted man of
action!

THE NOT SO GREAT DICTATOR, ACRYLIC ON CANVAS. PROMOTIONAL
PIECE.

When President George W. Bush said, "I'm the decider," I
heard, "I'm the dictator." This image is loosely modeled on
North Korean propaganda posters. I made up an overtly mil-
itaristic uniform like one an American dictator might wear.
The flag elements are no-brainers. I wanted a Chinese or
North Korean dictator–style collar and I added the belt, arm
band, and stylized eagle to give it a Nazi-ish flavor.

PORTRAITS

Informing the Viewer about the Subject

PEOPLE REALLY RESPOND TO FACES. I mean, everybody has one, and I think that people like seeing things they recognize. Also, faces are pretty easy to read. Anger, joy, hate, love, pain, and even sarcasm can be read on the human face, so when they see a face, folks already kind of know the story. For an illustrator, just showing a face does half the work.

Portraiture informs the viewer about the subject, so it figures that a lot of illustration jobs are portraits. How many *Time* magazine covers are portraits of famous people? And how many of those are illustrations? Lots!

The portrait of Willie Nelson opposite was created by Alex Fine to promote a Willie Nelson concert. I've shown you a few illustrations by Fine, and you'll notice that this one is different in style and tone. Here, he creates an inviting image by imposing the simple lines against large, graphic expanses of white and warm gray tones. The cropping and stillness give the piece an intimate feeling.

Of course, a photo of Willie Nelson could have been used instead, but there are many reasons why an art director might opt to run an illustrated portrait. Maybe the story is unflattering and the subject would never pose for a photo to accompany the article. Maybe it's too difficult to get access to the subject. Maybe the art director wants to show that person in a situation that tells the story but that could never be photographed. Or maybe the art

ALEX FINE, *WILLIE NELSON,* GRAPHITE AND INK WASH ON COLD PRESS PAPER. PUBLISHED IN THE *CITY PAPER* (BALTIMORE).

director wants an image that says something insightful about the subject and that stands out from all the other images of the person. Illustrated portraits are used so often that if you can do them, you'll definitely get work.

When doing portraits, I use photo references. It's completely legitimate to do so. In fact, unless the subject is sitting in front of you, you have no choice. But you shouldn't just copy somebody else's photo. That's not very interesting, and besides, you'd be infringing copyright and run the risk of being sued. I almost always try to refer to multiple photos when constructing the subject's face. I'm more interested in capturing the person's character and essence than in just replicating their image. Yes, it's extremely important that the illustration look like the person being portrayed, but there's more to it than just that. It is an illustration, after all.

If you can do portraits, you've got a license to print money.

Let's look at a few portraits I've done. The illustrations of Richard Nixon (ABOVE), John Waters (OPPOSITE LEFT), and Charles Manson (OPPOSITE RIGHT) are from a series on famous outsiders. For each, I used composition and background colors to inform the viewer about the subject.

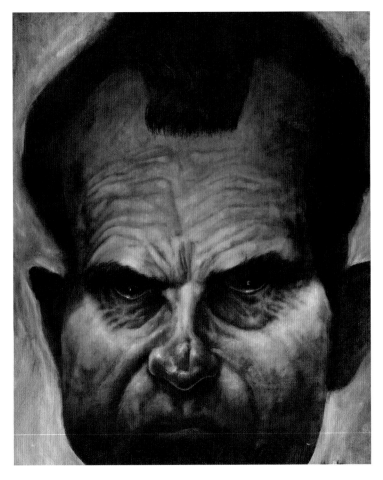

RICHARD NIXON, ACRYLIC ON CANVAS BOARD. PROMOTIONAL PIECE.

President Nixon was a dodgy guy. Calculating and smart, he rose to prominence despite his nearly crippling social awkwardness. For my portrait, I placed him firmly in the center of the space, cropping the face at the top and bottom to make him seem closer and more ominous. Nixon's famous five o'clock shadow helps create an overall darkness and adds weight to the dominant head. His eyes are hooded. The colors are cold.

Filmmaker Waters rode his outrageous movies to mainstream fame and fortune. He was a badass. I

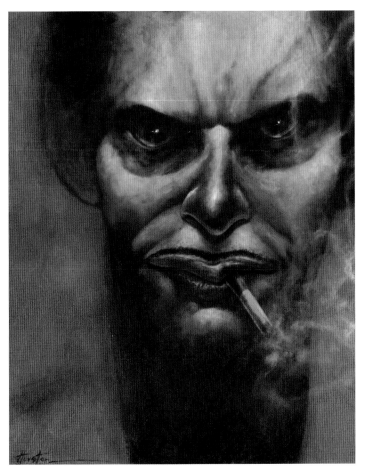

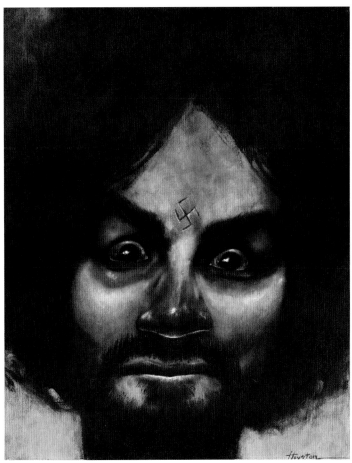

JOHN WATERS, ACRYLIC ON CANVAS BOARD. PROMOTIONAL PIECE.

CHARLES MANSON, ACRYLIC ON CANVAS BOARD. PROMOTIONAL PIECE.

chose to elongate his neck (he actually has a pretty long neck) and to place his face high to evoke his height. I included the cigarette because he was such a heavy smoker. (He once wrote that he wanted to *be* a cigarette.) The pink is a nod to his great early underground film *Pink Flamingos*. Though this and the portrait of Nixon are from the same series, notice the tonal difference.

Manson is a grotesque figure—a killer and a corruptor of young minds. Despite the atrocities perpetrated in his name, he is still a force in our culture. He fasci-

nates me. I put him dead center—the spot he occupied in the lives of his followers. I used the red to emphasize his insanity and chose the pea green to emphasize the sickening impact of his crimes. Manson gouged an X into his forehead during his famous murder trial (he "X'd" himself out of society), and, as if that weren't repellant enough, later turned the X into a swastika.

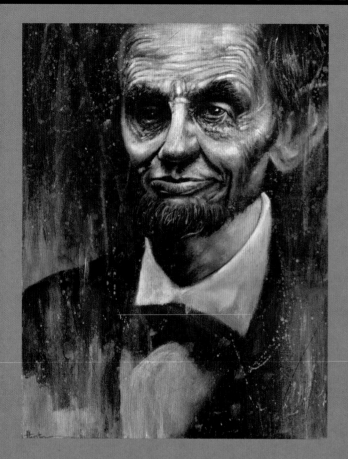

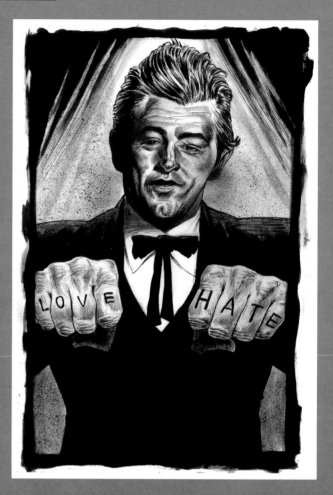

Here are some portraits that I've done over the years. I've tried to pick images that are stylistically or tonally different from one another to give you an idea of how many different ways you can do a portrait. Despite opinions to the contrary, portraits need not be staid or dull.

ABRAHAM LINCOLN, ACRYLIC ON CANVAS BOARD. PROMOTIONAL PIECE.

I wanted to do a traditional portrait of Lincoln in a nontraditional style that still fit the man. I chose a very limited and unnatural palette so that the image would seem old. The splatter and blurring accomplish twin goals: First, they make the image feel distant, as though the viewer is looking at him through layers of time. Second, because Lincoln wrestled with depression and had the weight of the world on his shoulders, I wanted to create some visual noise to indicate an unsettled mind.

ROBERT MITCHUM, INK ON PAPER. PROMOTIONAL PIECE.

Here's tough-guy actor Robert Mitchum in the best role of his career, the Rev. Harry Powell in the incomparable 1955 film *The Night of the Hunter*. I used the iconic costume and hair and included a background element reminiscent of the film's bedroom scene. Mitchum's tattooed knuckles tell a story of good and evil. I won't say any more. See this movie!

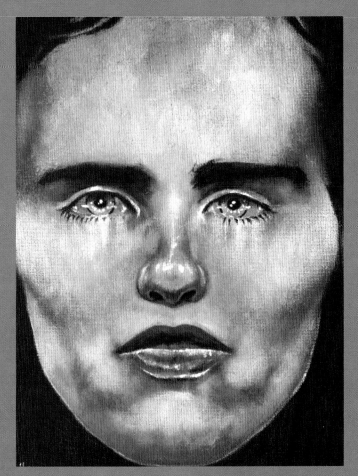

ELIZABETH SHORT, ACRYLIC ON CANVAS BOARD. PROMOTIONAL PIECE.

BLACK DAHLIA, ACRYLIC ON CANVAS BOARD. PROMOTIONAL PIECE.

There are some subjects that captivate you. You illustrate them again and again. For me, that subject is murder victim Elizabeth Short, also known as the Black Dahlia. Short's life ended in a gruesome, unsolved murder in Los Angeles in 1947. Her face was slit and her body cut into two pieces and left in a field. I've illustrated her like that. But the portrait here—where she's alive and tragic—really does her justice. I chose this extreme crop because I wanted her face to tell the story without aid from exterior elements. I wanted there to be an intimacy between the subject and the viewer—so close that you might hear her whisper her secrets.

Elizabeth Short again. As in the last illustration, I chose a blue palette. This image, though, is much more stylized and graphic. Her skin and the background are the same color. Her hair writhes as if under water. The concept is that, even while Short was alive, she was drowning under the weight of her life. As I mentioned, Short's face was slashed—nearly from ear to ear. Not wanting to replicate that graphic detail here, I used the bubbles (red to indicate blood) to broadly mimic the sweeping cut to her face.

PORTFOLIO: PORTRAITS

DIVINE, ACRYLIC ON CANVAS BOARD. PROMOTIONAL PIECE.

ALBERT FISH, ACRYLIC ON CANVAS BOARD. PROMOTIONAL PIECE.

I'm from Baltimore, so I have a legal obligation to paint Divine—the drag queen (created by Harris Glenn Milstead) who starred in many John Waters films. I just love Divine! She was the most beautiful woman in the world, and I wanted to show her in all her three-hundred-pound glory. Filling the space, the subject dominates the illustration. The gold head-dress creates a backstop and keeps the eye on the face. The black and pink elements create movement and radiate from the head area, drawing the eye back to the face. The arms and fists are intentionally flat and clunky, and the body is stubby and truncated so as not to pull attention downward.

Albert Fish kidnapped, killed, cooked, and ate three children in the 1920s. Fish was a religious fanatic, and he clearly struggled with his impulses. He was spindly and ragged; his face was hollow. I decided to portray him in the nude because his crimes were sexual in nature and because I wanted him stripped of a costume. The cracks in his body indicate his self-abuse. The frame is like a curtain made of intestines, pulled back to display Fish's true self. The knives and forks surrounding his head like a halo are nods to both his cannibalism and his religiosity. The straight needles inside his groin represent the dozens of needles that he'd actually inserted into himself; they were discovered when police X-rayed Fish before sending him to the electric chair.

DR. MARCEL PETIOT • DR. SATAN • 1945

DR. MARCEL PETIOT DR. SATAN 1945, ACRYLIC, COLORED PENCIL, AND INK ON PAPER. PROMOTIONAL PIECE.

Yes, another serial killer. (I'm weird.) This was from a series on killers and madmen. Dr. Marcel Petiot was both a murderer and a traitor to his country, France. I referred to a picture of him in which he looks tired, angry, and defiant. I used a muted palette to make the piece feel antiquated, cut into the paper with a razor to represent his bad, bad acts, and allowed his expression to indicate the kind of person he was.

ELIZABETH BATHORY, ACRYLIC ON CANVAS BOARD. PROMOTIONAL PIECE.

I have no idea what Elizabeth Bathory (1560–1614) looked like, nor do I care. I didn't want historical accuracy—I wanted to paint the legend. Nicknamed "Countess Dracula," Bathory believed that bathing in the blood of young women would keep her young, and she used her aristocratic position to collect hundreds of victims. I depict her as a very slim, pale person. The warm colors in her eyebrows and hair accentuate the cold of her face. The huge white collar visually severs her head from her body, making it appear as if her head is on a platter. Blood streams upward from the edges of her dress (which may be made of blood), and the cold background underscores her lack of humanity.

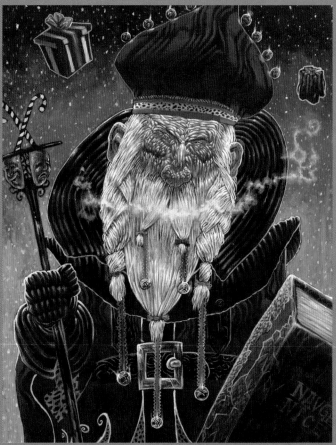

THE GREAT PUMPKIN, ACRYLIC ON CANVAS BOARD. PROMOTIONAL PIECE.

SANTA CLAUS, ACRYLIC ON CANVAS BOARD. PROMOTIONAL PIECE.

Portraits can be done of fictional characters, too. I wanted to create an image of *Peanuts* character Linus's oft-discussed but never seen Halloween legend, the Great Pumpkin. The concept was to treat the Great Pumpkin as if he were real. Imagining him to be ageless, I dressed him in clothes that put him roughly in the era of the Headless Horseman—the implication being that perhaps they are related in some way. I added the gold in the vest and lining of his coat, the tassels on his sleeves, and the staff to make him seem regal, possibly godlike. The joke is that, unlike the sweet, innocent *Peanuts* characters awaiting his arrival, the Great Pumpkin is a scary, possibly evil entity who may be better left unmet.

They say that St. Nicholas was a real guy from whose life the legend of Santa Claus grew. I wanted to conflate the two, creating a Santa Claus who appears old even at the dawn of time. To achieve this, I made him really wrinkly. His outfit has elements of both a military figure and a holy man—a warrior pope. I wanted his clothes to be luxurious and decorative, and I gave him an elaborately coiffed beard—all meant to feel like sacred symbols whose meanings have been lost. He has a staff indicating his high position as well as three other props—the huge, tattered naughty/ nice list, a piece of coal, and a present. The cold environment gives no clue to the time or place. He is cold, aloof, ancient, and judgmental.

AN INDIFFERENT GENTLEMAN, ACRYLIC ON CANVAS BOARD. PRO-
MOTIONAL PIECE.

This guy was also entirely made up. The point of the series
from which this piece comes was to illustrate as many char-
acters as I could using the same basic elements while making
them different from one another. This gentleman is kind of
ambivalent. His eyes are half shut and downcast. He's ex-
pressionless. His flat black suit gives him heft. His awkward
placement in the frame makes him feel noncommittal. Only
the messiness of his hair and the rigidity of his body create
any real dynamic. The only glimpse into his personality comes
from his props—an umbrella and watch chain. His tie and
vest seem strangely showy and imply a complex personality.

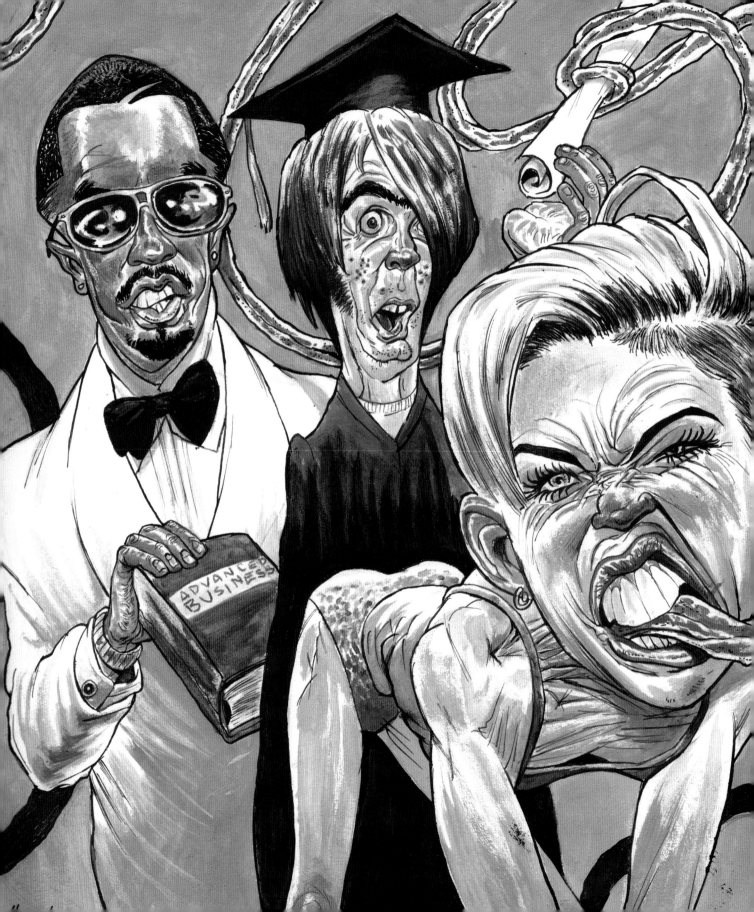

CARICATURES

Exaggerating and Amplifying the Subject

YOU MAY BE THINKING, "Caricature? Is this a kids' party? Am I on the boardwalk?" But caricature is an old and respected art form. It's also a staple of illustration assignments. Art directors often use caricatures for the same reason they use portraits. A great caricature is one that not only captures the subject's look and personality but amplifies them significantly. They are almost always funny and very often (but not always) mean spirited. I did the piece opposite for a *Village Voice* article about colleges offering courses on Miley Cyrus and Sean "Puff Daddy" Combs. Funny? I hope so. Mean spirited? Maybe just a bit. (Note the minor exaggeration of Cyrus's tongue.)

All caricatures are portraits but not all portraits are caricatures. As with portraiture, not every caricature is alike. The styles of the illustrators who create them vary tremendously, and the features or attributes that one artist chooses to exaggerate may be very different from another artist's choices. Part of the fun of caricatures is seeing how the same subject can be viewed through so many different lenses and still look like the actual person.

I used to do a lot of caricatures for the *City Papers* in Baltimore and Washington, D.C. Alternative papers tend to run a lot of stories that ruffle feathers, and creating the art

COLLEGE COURSES, ACRYLIC AND INK ON PAPER. PUBLISHED IN THE *VILLAGE VOICE.*

for those stories is always a lot of fun and affords great opportunity to roam stylistically and conceptually. The piece AT RIGHT was for an article lamenting the decrepitude of country music legends like Johnny Cash, Ray Price, and George Jones. I included props and costuming to help push the concept.

A caricature is easier to do when the person depicted is weird looking to begin with, and Bob Dylan is one weird-looking dude. The caricature BOTTOM RIGHT was for a review of an album Dylan had just released. I'd always thought Dylan's face and voice matched as well as or better than anybody else's, so I tried to capture his quirky, irreverent vocal qualities in the visual.

Like entertainers, politicians get caricatured *a lot,* and it's helpful when the politician you're caricaturing is a criminal, miscreant, or general ne'er-do-well. You don't feel much obligation to be nice. OPPOSITE LEFT is the former Illinois governor Rod Blagojevich, who left office in disgrace in 2009 for trying to sell the U.S. Senate seat vacated by Barack Obama (who'd just been elected president) to the highest bidder. The guy's face and hair made me think of bent hubcap. The trick was balancing the hair with the jaw. Once I got that, he just fell into place.

COUNTRY LEGEND RETIREMENT COMMUNITY, INK ON PAPER. PUBLISHED IN THE *CITY PAPER* (BALTIMORE).

BOB DYLAN, ACRYLIC AND INK ON PAPER. PUBLISHED IN THE *CITY PAPER* (BALTIMORE).

ROD BLAGOJEVICH, INK ON PAPER. PROMOTIONAL PIECE.

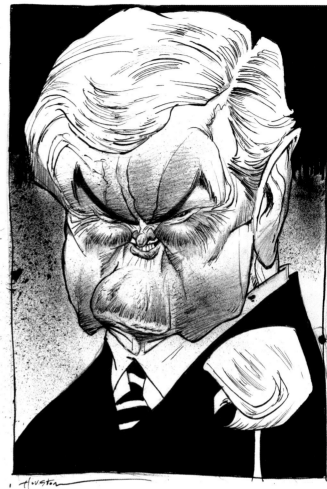

NEWT AND CALLISTA GINGRICH, INK ON PAPER. PROMOTIONAL PIECE.

In 2012, former speaker of the House Newt Gingrich decided that America needed him to be president. When he brought his newest wife, Callista, onto the campaign trail, she became fair game for caricature. I wanted to emphasize three things with this piece: First was what a strange pair they made—at least visually. Second was how mammoth Newt Gingrich's head—and, one may say, ego—is. Three was to show Callista as a sort of prop, which I feel she was intended to be.

I think former Texas governor and several-time presidential candidate Rick Perry is mean and not very bright, so the image of him ON THE NEXT PAGE left, in which he's just staring at the viewer, seems to capture the spirit of the man. I used that illustration as a template for the one ABOVE RIGHT. In 2014, Perry decided

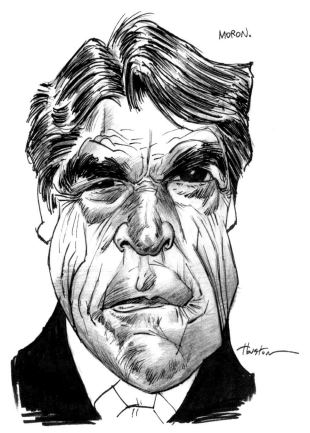

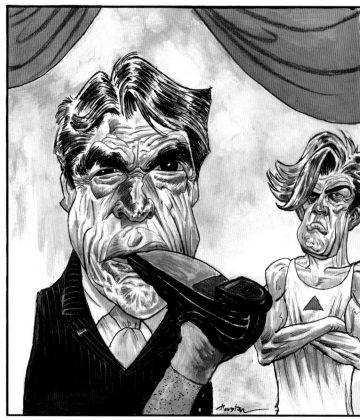

RICK PERRY, INK ON PAPER. PROMOTIONAL PIECE.

FOOT IN MOUTH, ACRYLIC AND INK ON PAPER. PUBLISHED IN THE *DALLAS OBSERVER.*

to go to San Francisco, of all places, to announce that he thought being gay was like being an alcoholic. Whoops! Note how the same, blank stare works for him in any illustration. It's all-purpose!

Poor Anthony Weiner. With that face, the last thing the U.S. congressman from New York needed was a sexting scandal. Illustrators and caricaturists smelled blood. The concept in the piece OPPOSITE LEFT is simple. I let his head do all the work, and the punch line was almost an afterthought.

New Jersey governor Chris Christie says a lot of toxic things. In the caricature OPPOSITE BOTTOM RIGHT, the spit running down Christie's chin and the empty word balloon/black cloud make the point that he's out of control (rabid) and spews a lot of hate (the toxic cloud). He dominates the space and is pointing to indicate his aggressive, provocative nature. The frame strains to contain him and emphasizes his great mass. (Remember that stuff about borders and negative space?)

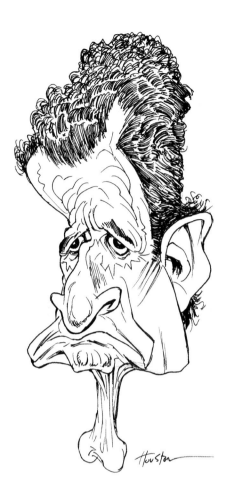

SAD WEINER, SHARPIE ON PAPER. PROMOTIONAL PIECE.

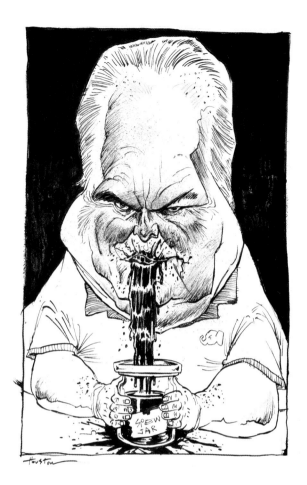

RUSH LIMBAUGH, INK ON PAPER. PROMOTIONAL PIECE.

Right-wing radio personality Rush Limbaugh isn't a politician per se, but he's of that ilk. ABOVE RIGHT, Limbaugh gets the caricature he deserves. His large body weighs down the bottom of the image, and his mammoth head dominates the space—just as in real life! I would have been satisfied with the image if I'd limited it to his physical attributes, but Limbaugh makes his living with the ugly opinions he lets loose on the world. Hence the spew jar.

CHRIS CHRISTIE, INK ON PAPER. PROMOTIONAL PIECE.

Now that we're warmed up, let's visit a few more famous faces that we've come to know (if not love). Remember, distortions should enhance the recognizability factor, not lessen it. Balance is everything: Clothes, props, environments, and activities should tell the viewer something about the person caricatured.

MICHAEL JACKSON, ACRYLIC ON CANVAS. PROMOTIONAL PIECE.

Whatever you thought of him, Michael Jackson was a strange individual. Not the MJ of the Jackson 5 era. We all loved that iteration. And not *Off the Wall* Michael. I'm talking about later, when he got his chimp Bubbles, became noseless, and started inviting children to his Neverland Ranch to sleep with him in bed. That's the version I chose to illustrate here. It's hard to caricature a caricature, and so I pushed the ick factor as high as it would go. It's just Michael enjoying a large children's lollipop. If the overly wet, overly long, overly agile tongue implies anything more, well, I'm sorry.

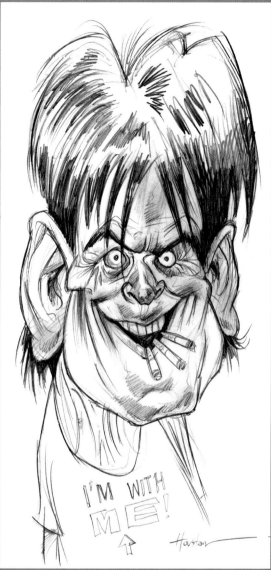

SCARY POPPINS, INK ON PAPER. PROMOTIONAL PIECE.

Another Michael Jackson. This time, I put him in a Mary Poppins–ish costume and setting to push the concept. The lollipops represent all things childlike, and he's got a young friend who's face has been obscured to protect his identity— as with all of Michael's young chums back in the day.

CHARLIE SHEEN, GRAPHITE ON PAPER. PROMOTIONAL PIECE.

Remember when actor Charlie Sheen was acting kind of insane? I wanted to show him at his winning-est best in this image. The intense expression, wide-open eyes, and three cigarettes were intended to give him a manic quality. I almost consider this one more of a straight portrait than a caricature.

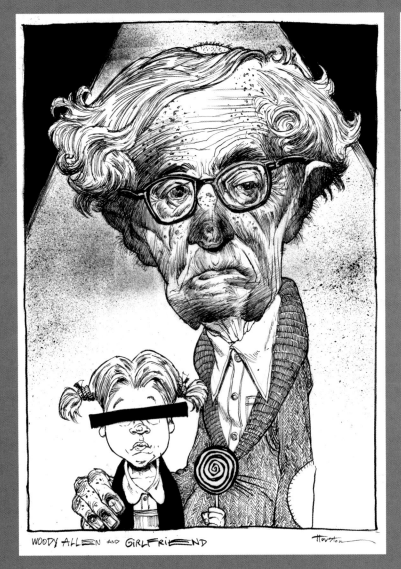

WOODY ALLEN AND GIRLFRIEND

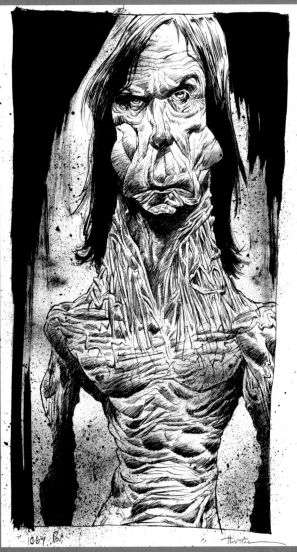

IGGY POP

WOODY ALLEN AND GIRLFRIEND, INK ON PAPER. PROMOTIONAL PIECE.

There's that lollipop again. I did this piece following allegations made against the "Woodman" by his former stepdaughter in 2014. Regardless of the accusations' veracity or lack thereof, I thought Allen's preoccupation with young women—emphasized here for effect—was worth commenting on in itself.

IGGY POP, INK ON PAPER. PROMOTIONAL PIECE.

Iggy Pop is pretty amazing. If I close my eyes and picture him, this is exactly how he appears to me. Iggy Pop is about line, line, line—the scratchier, the better. I added the dark areas to balance out the line and to create an interesting negative space. But this piece is all about the line language. Despite being fairly static, the piece has a lot of energy because the line language crackles.

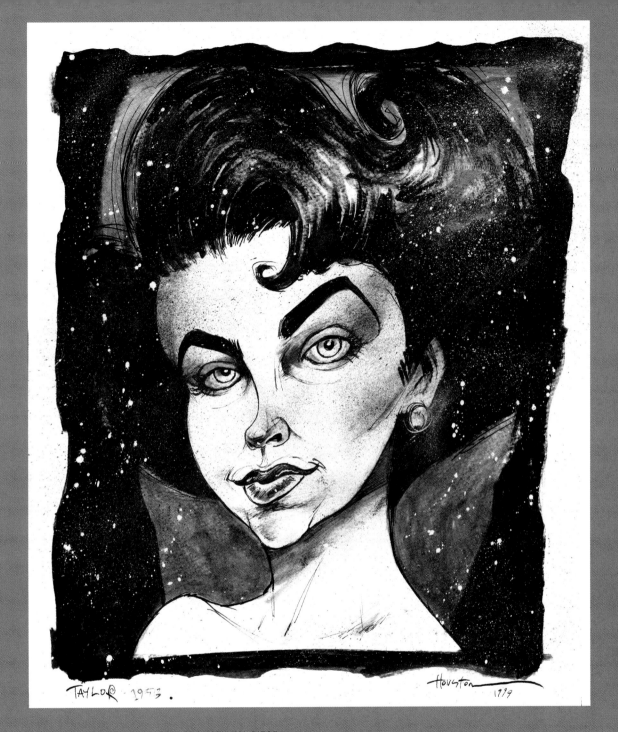

ELIZABETH TAYLOR 1958, INK ON PAPER. PROMOTIONAL PIECE.

Not every caricature has to be unflattering. This piece was from a series of old movie star portraits. Elizabeth Taylor was beautiful, and I chose to depict her at the height of her career. It's a caricature, so she's exaggerated—not to make her unattractive but to amplify the personality of the character she's playing: Maggie in *Cat on a Hot Tin Roof,* who's coquettish, playful, and a bit of a vixen.

DO A PORTRAIT ASSIGNMENT

In this assignment, you'll be illustrating a pair of identical twins. You're going to invent these characters. They can both be male, or they can both be female. They should be forty years old or older. The illustrations will be two separate pieces that go together. They'll both be full color and have a vertical orientation (any size), and you can use any medium you like.

The job is to do two portraits, one of each twin. Imagine that, at some point in the past, the twins' lives veered apart, putting them on very different paths. Perhaps one twin is rich and the other poor. Maybe one is happy and one unhappy. Perhaps one is a debauched gambler and the other a devout preacher. Who are they? What's their history? Where did they come from? What had their relationship with each other been like? What happened? Where and how did they diverge? How has each been treated by his or her life? What's gotten them to the places they are now?

Remember when I said that a portrait is actually an illustration? This is what I meant. In illustrating the twins, think about how life has aged them. Think about what they do for a living. Where they live. Their men- and emotional state. Design

Double your fun!

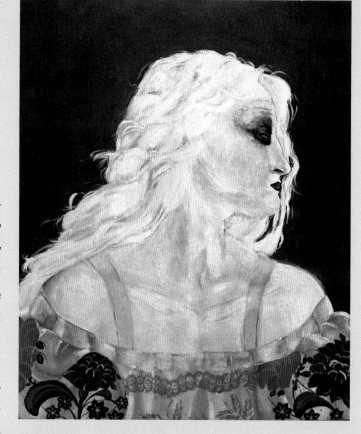

JILL KACZAK, *TWINS*, 2012, ACRYLIC ON WOOD PANELS. CLASS ASSIGNMENT.

them accordingly. What is each wearing? How do they wear their hair? How does their appearance reflect their situations? In what kind of environments are you depicting them? Think, too, about the colors you choose for each. Consider the medium and techniques you use. What about the lighting and composition? What do these elements say about the subjects?

The pieces ABOVE AND OPPOSITE show how a former student of mine, Jill Kaczak, did the assignment. Talking about the backstory that inspired her work, Jill says, "My concept was twin brothers who live on a farm, but one is kidnapped and becomes the fixation of a cult." As you can see, the lives of your twins can take many unexpected twists and turns! Feel free to use Jill's pieces for inspiration, but be original.

PROBLEMS AND MISTAKES

Avoiding Them, Correcting Them, and Learning from Them

FOR A LONG TIME, I taught in a summer pre-college program, and I used to give a sequential assignment that required the students to illustrate someone engaged in an activity that would unfold in four separate images. One girl illustrated a boy going through his morning routine. Illustration number one showed him waking up. Illustration two showed him getting dressed. Illustration three showed him standing on a street corner. Illustration four showed him getting on a school bus.

All this was great—except for the third illustration. In that piece, she showed the boy standing there, both hands thrust deep into his pockets, his eyes closed and with a goofy smile on his face. I don't have the illustration any longer, but it looked kind of like the drawing opposite. Her intention was to show him enjoying music while he waited for the school bus. Unfortunately, she had drawn a boy standing on a street corner, masturbating furiously. I saw it. *Every other student* in the room saw it. The only one who didn't see it was the poor girl who drew it. When another student nervously pointed out what was obvious to the rest of us, the artist turned beet red and started sputtering an apology. This kind of unintentional messaging is an illustrator's nightmare.

THINGS ARE NOT ALWAYS AS THEY SEEM.

BEWARE THE UNINTENTIONAL IMAGE

Now, everybody suffers bouts of accidental masturbation. It happens. The trick is to recognize and correct it before you finish the piece. Just to be clear, when I say "accidental masurbation," I'm referring to any image that, due to a glaring miscalculation, unintentionally illustrates something completely different from what the artist intended. It could be anything.

At RIGHT is an actual example, again from one of my summer classes. A student named Byron Otis drew this, in ten minutes, in response to the same "pro-censorship" assignment that I gave you back on page 43. Before we discuss the image, let me say that Byron was a terrific student—and is a brilliant artist—and I thank him for allowing me to use this picture as an example. Byron was trying to show that censorship was good because, as a result of it, the woman (representing censorship) has prevented the child (the public) from gravitating toward an unhealthy ideology (Nazism). Pretty straightforward. Nazis are bad, and by keeping this kid from getting his hands on the book (Hitler's autobiography, *Mein Kampf*), the mother (censorship) has saved his soul. The end, right?

Nope. Look at the mother's expression. Does she seem worried? See the closed eyes and slight smile? She looks happy or relieved about something. And look at her pose. Is she holding the boy back? She doesn't appear to be struggling against his momentum. He's not moving forward—his weight is on his back foot. Actually, her arms are lightly draped around him, as if she's gently hugging rather than restraining him. The boy's hand is raised toward the book, but is he reaching—or saluting? And, finally, where are they? Absent any other visual clues, it's easy to assume that they are in their

home, which inexplicably has a copy of *Mein Kampf* displayed on the table. Taking all the visual cues together, does it seem more likely that this image is showing (1) a mother who is stopping her child from reading *Mein Kampf,* or (2) a neo-Nazi mom relieved that her young son is following in her footsteps by giving a Nazi salute to the copy of *Mein Kampf* that she has so proudly displayed in her home? Ladies and gentlemen, I give you accidental masturbation!

Even if you think I'm stretching it, the lack of clarity in this scene leaves too much room for interpretation. An illustrator has to communicate the concept *clearly*. You don't have to bludgeon the viewer, but the concept can't get lost or muddled. That's the antithesis of your goal.

To be fair to Byron, here's an image of his, RIGHT, that wasn't created in just ten minutes. See, even a talented artist like this might accidentally create pro-Nazi propaganda!

When you're working on an illustration, it's a good idea to take an occasional break. Put the piece on the wall and take a look at it from a distance. Try to divorce yourself from it for a couple of minutes and then look at it with fresh eyes. Are unintentional things happening? Do you see any opportunity for multiple interpretations? These things happen to the best of us, but you

BYRON OTIS, *THE PINK LADY,* COLORED PENCIL ON PAPER. CLASS ASSIGNMENT.

can mitigate the damage if you're on the lookout for it. Check it again when it's finished. It never hurts to be thorough and thoughtful.

BAD ANATOMY

Unfortunately, there are problems besides accidental masturbation. Poor drawing can sink your work. I said in chapter 10 that it's important to know how to draw hair and clothes. But there's something even more basic than that, which, if you get it wrong, will destroy your piece.

I'm talking about *anatomy*. We all have it. It may not be pretty, but it's there. And people easily recognize mistakes in human anatomy. Granted, the average person might not be able to tell you if your drawing of a Kitti's hog-nosed bat is on the money. How many people would have any idea what such a bat even looks like? But anybody will immediately see that you've drawn a right hand on the left side of the body. Why? Because people have hands!

Anatomy is the easiest thing to draw badly. ABOVE RIGHT and OPPOSITE TOP LEFT and BOTTOM are some examples of bad anatomy—the kinds of mistakes I see all the time.

Badly drawn heads and faces are even worse. Consider my bad self-portrait, OPPOSITE TOP RIGHT. You know, your face occupies just a small part of your head. And human eyes are not giant, lidless almond shapes containing large circles with straight lines radiating out

BADLY DRAWN ARMS. Arms don't look like this. I don't care how muscular you are, your arms still include shoulders, biceps, and forearms. People would be paying money to look at this guy if he were real.

I'm not feeling quite myself today.

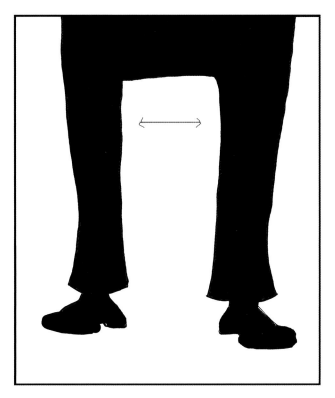

BADLY DRAWN LEGS. That's a lot of space between this guy's legs. I'm not saying it couldn't happen, but where does this guy buy pants?

A BAD SELF-PORTRAIT

BADLY DRAWN ARMS IN A BADLY DRAWN SUIT. Remember the poorly drawn man's suit (page 141)? You'd be surprised how many of those are worn by guys with arms like these.

from pinholes in the center. Although I have to admit that I actually encountered a guy in college who looked exactly like a badly drawn self-portrait. I'm talking huge face, tiny head, humongous almond-shaped eyes—all the things I just warned you about. It was crazy! I only saw him twice, but I dubbed him "Bad Self-Portrait Guy." (I've tried to capture his look in the drawing RIGHT.) I have to believe he was some sort of fairy godfather for the untalented and that he showed up at art schools to give hope to people who couldn't draw portraits. ("What do you mean people don't look like this? Look at that guy!") Curse you, Bad Self-Portrait Guy! Look at the damage you've caused!

I want to make something clear. As an artist you have every right to develop whatever style you want. And if you make a creative decision to draw someone badly, do it, by all means. But that decision should be just that—a *decision,* an intentional choice. You should be able to draw a face correctly and then choose to draw it badly in order to make a point or reinforce a concept. If you can only draw badly, you're not making a stylistic decision. You're just drawing badly.

And remember that, as an illustrator, you are in charge of the image. You create the world you illustrate, and you're responsible for communicating that world to an audience. Of course, you'll never get 100

"BAD SELF-PORTRAIT GUY"

percent of any group to see something the same way. You could draw a smiley face and 10 percent of the people who look at it would see the devil riding a mule. People are strange. But your job is to communicate visually, and you're responsible for making illustrations that will make most reasonable people get the gist of a story or concept. If you break the rules for effect and the piece reads, then you've done your job. If the piece doesn't read, you've failed. Illustration isn't about good or bad. It's about success or failure in communicating. Period.

LEARNING FROM MISTAKES

We all make mistakes. It's just going to happen. The key is to embrace failure and learn from it. The work of mine I've shown you up to now is all finished product. But nearly every piece that I've included has a hideous sibling that came before it. There's almost always some kind of misfire, some early step in the process that was ill considered or poorly executed. Sometimes it's not even a matter of the work being bad—it just may not be what you want. When that happens, you need to make adjustments or, if necessary, start over. The trick is to know when to push ahead and when to scrap what you have and take another crack at it. Sometimes what you initially consider a mistake can actually lead to a new concept, technique, or style, so be thoughtful about what's on your paper before you trash it. For those times when the work truly stinks, don't be too hard on yourself. Adjust. Move on.

As an illustrator you'll quickly come to realize that plenty of people are judging your work—art directors, creative directors, editors, publishers, marketing people, lawyers, clients, the audience—the list is dizzying. But the first judge, the one who decides if it even gets out of your studio, is you. You need to decide whether or not the piece is working before anyone else ever sees it.

Remember that, these days, a piece that's published will live forever on the Internet. If you're willing to put your name on your work, you'd better be damn sure you're happy with it. Every job has restrictions, and sometimes what satisfies the client may not necessarily satisfy you. Remember, you have no taste! It's not about your aesthetic. But you still have an obligation to the client to make the best piece of art possible. You have that same obligation to yourself. So be a tough editor of your own work. Make sure that whether or not it's your favorite piece, it's professional, is well crafted, communicates the concept, and is something that you can stand behind.

Finally. The perfect picture.

THE PERFECT ILLUSTRATION? NO SUCH THING

Like Yeti, Big Foot, or a quality Johnny Knoxville film, the perfect illustration does not exist. There is no such thing as the perfect illustration. Why? Because every job is different, and each requires its own unique solution. What works for a story about a murdered Albanian immigrant will be very different from what works for a children's book about the importance of sharing. These jobs shouldn't be approached the same way, and a good illustrator wouldn't go about solving them the same way. Writer Ian Fleming wrote the James Bond books *and* the children's book *Chitty Chitty Bang Bang,* but he handled them very differently. For one thing, there's less sex and killing in the children's book.

Illustration is no different. You have to think about what's right for each particular job in terms of style, medium, composition, and concept, and then you've got to communicate the story clearly and appropriately. The way you get there depends on the subject matter, your imagination, and your skills. Don't be cowed by a blank piece of paper. The illustration you make doesn't have to be perfect—it can't be. It just needs to work.

It ain't gonna happen.

There are as many ways to do a great illustration as there are illustrators. The evidence is abundant. Just go to any Society of Illustrators show or look at any illustration annual. For that matter, open any magazine or newspaper. Great work is everywhere. But perfection is a mirage.

PORTFOLIO: MY OWN MONSTROSITIES

I suspect you still don't believe that I'm not perfect. Okay, I'll prove it. We're going to check out some of my own monstrosities, as well as some cases where I abandoned my first idea because I thought of a better one. If I can rebound from a bad idea or image, so can you. Nothing should go to the client until you feel good about it. But never forget that something *does* need to get to the client—and by the deadline—so be aware of how much time you need to do a piece. That will help you decide whether to push on or restart. If you've finished a piece that you aren't wild about but can live with, and if you still have some time, you might try doing a second version. If you're ultimately unable to finish it, at least you'll still have the first one to send in. Don't let perfectionism stop you from getting the job to the client, but don't let ambivalence stop you from making great work.

These two pieces are my first and second tries for an illustration I call *She of 1,000 Cats,* created for a show that benefited an animal rescue. Sometimes you just get a better idea midstream, so I abandoned the one on the left. My concept stayed basically the same, but the way I chose to show it changed dramatically.

She of 100 CATS Houston

Remember the *Cabinet of Dr. Caligari* piece I showed you (page 97)? Well, sometimes I get too excited about getting to the inks and jump ahead before I settle the pencils. That's not always a problem. But the piece on the left is a good example of my going to the inks way too fast. You can see from there that I hadn't really committed to my composition. A lot changed from the illustration on the left to the one on the right, including the face, hair, and stance of the Caligari character (in the foreground). The Cesare character (in the cabinet) went though a pretty severe evolution, too. The biggest difference is the composition. By tilting Cesare's cabinet to the left, bringing Caligari's arms up, and including the three spirals, I created a much better, more interesting dynamic and did a better job of telling the story. Caligari is a showman. He hypnotizes people. The eye should be forced to return to him. He *commands* it!

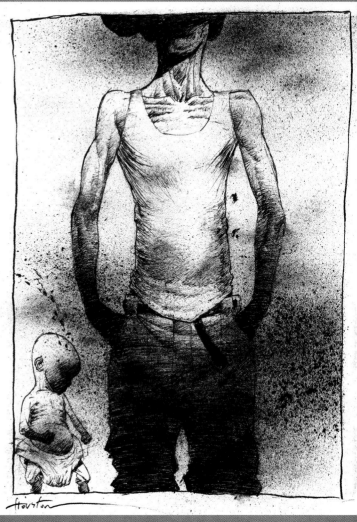

Here are earlier and later versions of the young father from my *Dead Baby* series. You may recall from chapter 4 that the editors wanted me to redesign the clothes for the parents. But before we even got that far, I had scrapped the version of the father on the left. The anatomy is atrocious. I just didn't like it at all, so I redrew it.

These are before and after versions of my *Peace Rally* illustration (see page 57). As I worked on the first iteration, at left, I grew to dislike the placement of the main character. And he's too stiff. So I redrew the piece, tilted him at a sharper angle. I also reduced the width of the character to make him seem weaker and less of a match for the cops.

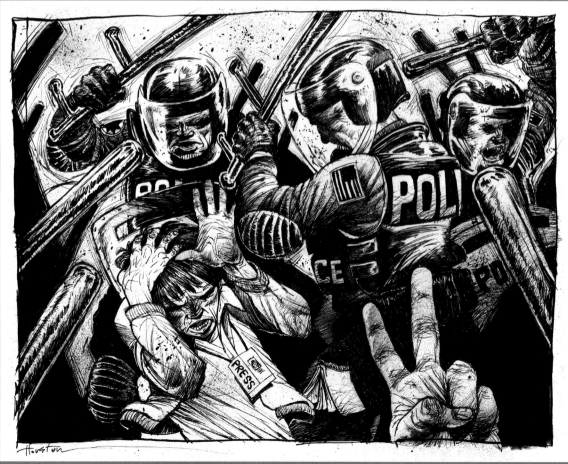

My "Best and Worst of 2013" cover for the *Dallas Observer* took a drastic turn. Initially, I wanted the cab-driver character to seem demon-like, so I thinned him out and added those stupid pointed ears you can see in the piece above. But once I started painting, I didn't like the way it was coming together and started over. I dumped the demon aspect and thickened the head to make the skull broader and heavier, and I let the decaying meat add even more volume and heft to the zombie cabbie. (You might have noticed that these two pieces don't have the same proportions. Well, they did, but when I started over, I cut out the unused portion of the initial sheet and used it for another job. Never waste paper.)

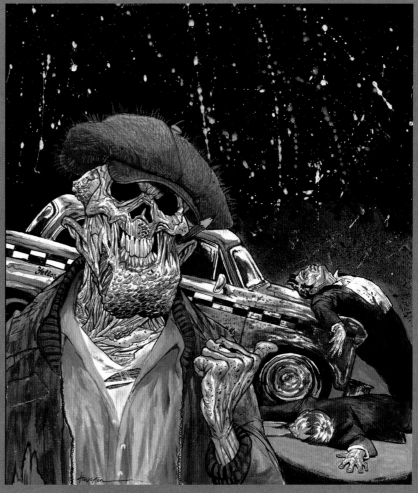

ILLUSTRATE TWO RELATED THEATER POSTERS

And so it's come to this, the last assignment in the book. Are you up to the challenge?

Here's the situation: You hear from an art director who needs two different posters for two different productions of Shakespeare's *Romeo and Juliet.* Why two posters? Because the first will be for a traditional version of the play, and the second will be for a version that's been altered in some nontraditional way—maybe it's updated to modern times, or takes place in the old West or in another dimension, or features an all-female cast, or whatever. The printed pieces will be 24 by 20 inches, with a vertical orientation. They can be full color, limited color, or black and white—whatever works best for the concept. There will be text on both posters (title, actors, location, ticket prices, date, time) but you won't be responsible for including the text. Just design your pieces accordingly.

Here's the logic behind this assignment: When I give it to my classes, the students inevitably grouse about the posters being for *Romeo and Juliet.* It's boring. It's been done before. But that's exactly the point! Everybody's familiar with the play, so it's not something you need to read before beginning work. And

Take a stab at this one!

SARA LYNGE, POSTER FOR *ROMEO AND JULIET* (NONTRADITIONAL), DIGITAL. CLASS ASSIGNMENT.

because it's been done to death, making it fresh is a challenge—especially for the traditional version. For the second poster, you get a chance to go wild. How can you push the concept and the art to make something both familiar and totally new?

Because you're illustrating posters, you should work large. And think about what the TV-series poster assignment (page 136) taught you about mediums.

The two pieces here were created by a former student, Sara Lynge, for this assignment. Let's look at the nontraditional piece first. In this beautiful illustration, Sara updated the play by making Romeo and Juliet an interracial couple. It works because Lynge made all the

right decisions. First of all, she did the piece in black and white. (The silhouettes were a stroke of genius.) But the piece also works because of the delicate balance she created between white and black areas and between the faces, lines, birds, and gray background. If anything were out of whack, the whole piece would fall apart.

Now look at the traditional version. The way Sara visually connected the pieces was really smart. Both are simple, graphic. Both are black and white. Both keep the couple's faces obscured in some way (in the traditional version, faces are not shown at all), and both contain clues regarding the era in which the play takes place—the telephone wires and hairdos of the couple in nontraditional version, the sleeves and stone floor in the traditional piece. Super smart. Hopefully, Sara's work will put the job into some context and inspire you.

Now it's your turn to amaze. Begin!

SARA LYNGE, POSTER FOR *ROMEO AND JULIET* (TRADITIONAL), DIGITAL. CLASS ASSIGNMENT.

DON'T JUST
FEED THE ALLIGATOR

Creating Work for Yourself

DURING MY JUNIOR YEAR at the Pratt Institute, a few of us students were talking with one of our professors, the great Dave Passalacqua. At some point during our conversation, Dave said to us, "Remember, don't just feed the alligator." Now, we all knew that Dave was a genius illustrator and we were eager to hear whatever words of wisdom he was willing to impart. But this was pretty cryptic.

What he meant, I now understand, was that we should always be working for ourselves while working for "the man." It's not enough to look for and wait for work. We should also be doing our own thing—creating our own markets and not just feeding the alligator.

This was great advice. Over the years I've gotten through some lean times by creating my own work and developing new markets for myself. Besides constantly creating new images for my portfolio—like the portrait of Dracula, opposite—I also began writing and illustrating graphic novels, pushing myself artistically by doing landscape paintings, pitching animated shows, illustrating designs for T-shirts and posters, and starting my own publishing company. When I'm not working, I'm working.

None of these sidelines has made me rich, but they've paid off in a variety of ways. The two graphic novels I did brought attention that resulted in other illustration jobs. The

DRACULA, ACRYLIC ON CANVAS BOARD. PROMOTIONAL PIECE.

BLUE TREE #1, ACRYLIC ON CANVAS BOARD. PROMOTIONAL PIECE.

BLUE TREE #2, ACRYLIC ON CANVAS BOARD. PROMOTIONAL PIECE.

illustrations I regularly create for my portfolio freshen it and also lead to new gigs. The landscape paintings led to my teaching an online class at Craftsy.com. And my wife and I sell T-shirt designs through our online stores.

Dave was right. By not simply feeding the alligator, I've expanded as an artist and as a brand.

I started doing landscapes like those ABOVE AND OPPOSITE LEFT because I was commissioned to do one.

What's with the sandwich? I want to eat *you!*

LANDSCAPE #9, ACRYLIC ON CANVAS BOARD. PROMOTIONAL PIECE.

I wasn't a fan of landscape paintings, but I found that because I hadn't really done them before, I hadn't set a bar for myself. This was liberating. I freely experimented with color and composition. When I started posting them on my site, they led to more commissions.

Also, doing landscapes ignited an interest in using them as backgrounds, and I started bringing this element into my illustration work. ABOVE RIGHT is an image of a drowned woman. The trees are reflected on the surface of the water. By including the tree line, I meant to create some visual confusion, keeping the viewer from

SWIMMING IN TREES, ACRYLIC ON CANVAS BOARD. PROMOTIONAL PIECE.

immediately realizing that the woman is under water. Had I not started painting landscapes, I would never have done this piece.

GREEN RIVER KILLER, ACRYLIC ON CANVAS BOARD. PROMOTIONAL PIECE.

ELECTRIC TREE, ACRYLIC ON CANVAS BOARD. PROMOTIONAL PIECE.

My experience with landscapes also enabled me to do the portrait, ABOVE LEFT, of serial murderer Gary Ridgway, known as the Green River Killer. It meant I could place him in the environment for which he was nicknamed.

With the piece ABOVE RIGHT, I was experimenting. Because I was doing a lot of landscape paintings (mostly trees), I was thinking about trees' anatomy. At some point, the words *tree* and *electricity* melded in my head—*electricitree*—and I thought it would be interesting to paint the tree as both an organic life form and a fake version of the same thing, kind of like a plastic Christmas tree. Now, I want one for my yard.

The piece OPPOSITE is from a series of illustrations on gangland murders. Even though the image is bereft of trees, it wouldn't have happened the way it did if I hadn't been thinking about using landscapes as settings.

KANSAS SKY,
ACRYLIC
ON CANVAS
BOARD.
PROMOTIONAL
PIECE.

KATE TALBOT, *LIBIDO,* FABRIC SCRAPS SEWN ON WHITE COTTON, WITH EMBROIDERY. PROMOTIONAL PIECE.

KATE TALBOT, *HEINZ BAKED BEANZ,* CROCHET AND EMBROIDERY. PROMOTIONAL PIECE.

Let's also look at some promotional work that other illustrators have made for their portfolios when they haven't been busy feeding the alligator. Tired of being pigeonholed creatively, Kate Talbot is always making new work for her site to show art directors the scope of her talent. As she did in *Round the Block* (page 89), Talbot used fabric to make an image, ABOVE LEFT, that has the flat look of a comic panel. Here, she chose printed textiles for the carpet, the back wall, and the area beyond the door to create an interesting and informative negative space.

For the piece ABOVE RIGHT, Talbot returned to the sculptural work that she used in the *Perfumes* illustration on page 88. Playful and imaginative, her sense of fun elevates the subject and makes the piece that much more delightful.

CLOCKWISE FROM ABOVE:

JACQUELINE WADSWORTH. *ELEMENTS OF A HAPPY LIFE (FUCHSIA)—MONKEY IN A PEACHTREE,* EMBROIDERY AND APPLIQUÉ. PROMOTIONAL PIECE.

JACQUELINE WADSWORTH. *ELEMENTS OF A HAPPY LIFE (LIGHT BLUE)—PERSON RIDING A LION,* EMBROIDERY AND APPLIQUÉ. PROMOTIONAL PIECE.

JACQUELINE WADSWORTH. *ELEMENTS OF A HAPPY LIFE (GREEN)—SNAKE WOMAN,* EMBROIDERY AND APPLIQUÉ. PROMOTIONAL PIECE.

On this page are some more images from Jacqueline Wadsworth's *Elements of a Happy Life* series, to which you were introduced on page 88. Here's the artist herself talking about the origin and concept for the series: "The idea for these illustrations came about when I was in Chinatown and saw Chinese peasant folk-art embroidery.

TED PAPOULAS, *MOTHER'S DAY AT THE AMUSEMENT PARK,* ACRYLIC ON CANVAS BOARD. PROMOTIONAL PIECE.

I wanted to try to replicate these embroidery techniques, so I chose to illustrate ideas in Chinese peasant culture about what determines a happy life. In these illustrations I use authentic Chinese embroidery stitches and appliqué. Each illustration depicts symbols of a happy life."

Ted Papoulas loves to paint scenes—city scenes, subway scenes, food scenes, rural scenes, underwater scenes. The illustration ABOVE was from a photo he took of his family enjoying a day at Coney Island. I've always loved this piece. The flat, blue sky is so stark and immense, and the architecture of the amusement

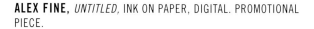

ALEX FINE, *UNTITLED,* INK ON PAPER, DIGITAL. PROMOTIONAL PIECE.

SAM MARTINE, *SEATED 1,* CHARCOAL ON PAPER. COPYRIGHT BY SAM MARTINE.

ride pops strongly against it. The joy on the faces of the riders is so real, and the split second captured here is one of absolute delight.

Alex Fine originally created the piece ABOVE LEFT for a show about vending machines, then decided to use it for his business cards. The job of an image on a business card is to get attention. This certainly got my attention. Well done!

The beautiful drawing ABOVE RIGHT is by illustrator Sam Martine. I feel it's important to include it because Martine's drawing shows that the best way to master your art is to continue to work at it. Understanding anatomy, color, and line is crucial for a good illustrator, so revisiting, revising, or reinventing your technique—whether it's drawing or painting—is a must. Despite the fact that he could probably draw flawless anatomy in his sleep, Martine often goes back to basics—drawing from the model. The result? Just take a look at the drawing. The balance of the weight is gorgeous; the economy of line is elegant yet informative; and the language of the line—the thickness at the top of the left thigh, the breaks in the pant leg and at the top of the head—is just so stylish. If you want to be the best, you, too, will *draw, draw, draw*!

PORTFOLIO: FEEDING MYSELF INSTEAD OF THE ALLIGATOR

I hope I've done a decent job of explaining that, as an illustrator, you need to work to the client's needs, not your own. Still, every illustrator is an artist, and every artist needs to explore his or her creative impulses. In my case, I see everything as a story to be told visually, so I create illustrations even when working for myself. By doing this, I keep my portfolio fresh and am able to show art directors work that they've never seen. Win-win.

EAT UP, AMERICA! ACRYLIC ON CANVAS. PROMOTIONAL PIECE.

This illustration is about the alarming trend of obesity among Americans. I exaggerated the character to make his body shocking. The bib and utensils accomplish two tasks: The flag bib clearly indicates this is about America, and the utensils give the character a "ready to eat" look. The junk food swirling about his head introduces the concept of a poor diet, and the composition moves the eye around the piece, preventing the character's domination of the space from becoming static.

FROM MY BOOK *CRAWL.* INK AND WHITE INK ON PAPER WITH RAZOR CUTS.

SMILE, INK ON PAPER. CREATED FOR THE SELF-PUBLISHED ILLUS-
TRATED BOOK *CRAWL* (2007).

This is one of seventy-five pieces I created for an illustrated
book because I felt I needed to reach a different audience.
It and the other images are very conceptual; they all exist in
a strange netherworld, out of place and time, and they all
feature personifications of sexual fetishes, which range from
beautiful to grotesque. This one fits in the latter category.

LEE MARVIN, CHARCOAL PENCIL ON PAPER. PROMOTIONAL PIECE.

This portrait of actor Lee Marvin is from a series of portraits of
movie tough guys of the 1960s and 1970s. I wanted to revisit
a medium—charcoal pencil—that I hadn't worked in for eons
to illustrate some iconic faces.

COVER OF *VATICAN HUSTLE*, ACRYLIC, INK, COLLAGE, AND DIGITAL.

COVER OF *ELEPHANT MAN #1*, ACRYLIC, INK, AND DIGITAL.

These are the covers for my first (left) and second (right) graphic novels. Doing these led to a few more books and to the classes on sequential illustration that I now teach.

10

INTERIOR PAGE FOR *VATICAN HUSTLE,* INK AND SHARPIE ON PAPER.

And I'm sure you'd like to see an interior page, too, so here it is.

DRACULA, ACRYLIC ON CANVAS BOARD. PROMOTIONAL PIECE.

I believe in reimagining existing characters. When people visit your website, their attention is grabbed by characters they recognize. And reimagining existing characters showcases your sensibilities, letting art directors see how you'd tackle a familiar character. Please note that I am *not* advocating ripping off other artist's characters. If you're basing a piece on a copyrighted character, do *not* reproduce and sell it, because doing so would violate copyright laws. Do it only to challenge yourself as an illustrator and to gin up interest in your work. This piece is of a non-copyrighted character, Dracula. Is there any character in literature who's more iconic? I'm depicting him here with a couple of his victims. While the characters are handled in a realistic way, the background elements are much more stylized. The gray and black of the thorny vines symbolize the undead—an organic design with inorganic color and stylization.

JACK THE RIPPER, ACRYLIC ON CANVAS. PROMOTIONAL PIECE.

JACK THE RIPPER, ACRYLIC, INK, AND COLORED PENCIL ON PAPER. PROMOTIONAL PIECE.

Here are two different imaginings of Jack the Ripper. The version on the left is a nod to the Jack the Ripper character of popular imagination, replete with top hat, cloak, and doctor's bag—none of which the real killer probably wore or carried. I gave him the horrific expression to complete the fantasy. I suspect that the image on the right is much closer to the historical person—unremarkable, except for his murderous compulsion.

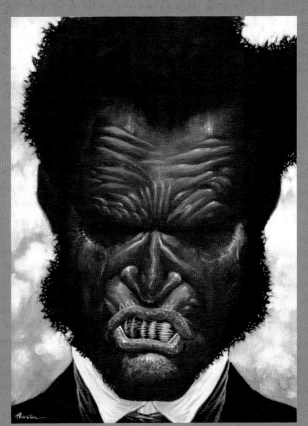

CANDYMAN, ACRYLIC ON CANVAS BOARD. PROMOTIONAL PIECE.

FRANKENSTEIN, ACRYLIC ON CANVAS BOARD. PROMOTIONAL PIECE.

This is not Mary Shelley's Frankenstein. It's based on David Carradine's character from the 1975 cult-classic film *Death Race 2000.* Because I am so enamored of the film, I wanted to reimagine the characters in a vastly different way—but without changing their fundamental qualities. Carradine's Frankenstein is rumored to be stitched together like Shelley's monster, so I decided to reflect that in his costume. Here, Frankenstein wears a racing uniform that's a combination of disparate materials and textures. I posed him in a stiff, un-natural stance to underscore the man/monster quality of the character in the old Universal *Frankenstein* films. His arms are starting to rise in the sleepwalker-like pose that Boris Karloff made famous. Since the plot of the film involves futuris-tic auto racers and a bloody cross-country trek in crazy theme cars, I wanted to include some visual element as a nod to the story. Here the smeary black and brown of the background suggests an oil slick.

One last piece. I never liked the film *Candyman.* The 1992 horror movie is stupid and the Candyman character isn't frightening, but I do like the premise. According to legend, Candyman was a young artist living in post–Civil War New Orleans. He painted a portrait of a girl—a rich guy's daughter, as I recall—and he and the girl fell in love. Not super-happy with this turn of events, the father had a mob beat the artist, cut off one of his hands, and chase him into an apiary, where thousands of bees stung him to death. Some kind of curse was invoked, and decades later, whenever anyone repeated his name aloud three times, he appeared—his torso a mass of bees—and killed the person.

I decided to reimagine Candyman as he might have looked when still alive. But he's *not* alive—he's a spirit or something, and he's filled with bees. He looks somewhat nor-mal, but his parted lips reveal one of the many huge bees that dwell inside his body. My concept is that he's like a piece of candy—a human shell with a bee-filled center. I like how subtly disturbing the image is.

EPILOGUE

The Coolest Job Ever

THERE ARE LOTS OF REALLY COOL JOBS IN THE WORLD—spy, daredevil, human cannonball, rodeo clown. But being an illustrator is just about the coolest thing ever. You get to meet and work with interesting, creative people. You learn about all sorts of amazing things. And sometimes an illustration job will even take you to unusual places. I've had assignments that required that I draw on site at locations as diverse as Leisure World (the largest retirement community in Maryland), a jail cell in Washington, D.C., and the set of the TV show *Homicide*. I've worked for clients in the fashion business, the comic book industry, politics, the news media, and the music industry, among others. Each job is new. Each challenge is fresh. In all the years I've been doing this professionally, I've never been bored.

Plus, you get paid for drawing and painting! Imagine that. Doing something you enjoy and being compensated financially for it. That's living!

Well, here we are, at the end of this book. I hope it wasn't too painful a read. I also hope that I've done a decent job in explaining both the art and the profession of illustration. As you may have guessed, I love illustration. I think it's a noble and fascinating art form. Maybe you'll agree and become an illustrator, too. The world can always use another talented illustrator—there are lots of stories left to tell.

Ladies and gentlemen, presenting the greatest job on earth!

ACKNOWLEDGMENTS

I'D LIKE TO THANK the following people for their support, friendship, and guidance: my wife, Tracy Jacobs (the book's also dedicated to her so this should keep me in her good graces for a while), and my parents (and role models), Richard and Constance Houston. All artists should be as fortunate as to have the kind of encouragement that I've gotten from them in my life and career. Amy, Chris, Alex, and Matthew Swanenburg, Rachel Jacobs, Edward Kane, Cary Anderson, Ted Papoulas, David Gillis, David Burton, Vivian Ng, Mike Yoder, Kelly Vetter, Jennifer Goldman, Lori Hamilton, Ronald X. Roberson, Jefferson Steele, Brennen Jensen, Joab Jackson, Heather Joslyn, Adele Marley, Scott Wallace Brown, Alex Fine, David Passalacqua, Donn Albright, Ruth Guzik, Rose Fabricant, Tom La Padula, Gerry Contreras, Sam Martine, Guiseppe San Fillipo, Joseph Hyde, Victoria Craven, James Waller, all the many amazing students that I've had the honor to teach, and the good people at public domain. I'd also like to thank the following institutions: Pratt Institute, the Walters Art Museum, the Getty Museum, the Delaware Museum of Art, and the Yale Archives. Thanks also to the Monacelli Press for giving me this opportunity. Lastly, I'd like to thank all the incredible artists whose works grace this book.

ILLUSTRATION CREDITS

Marshall Arisman: 117
Steve Brodner: 21
David Burton: 81
Georges Jules Victor Clairin: 33
Bill Cotter: 83
Thomas Couture: 37
Honoré Daumier: 40
Edgar Degas: 38
Clare DeZutti: 137
Alex Fine: 29, 52, 90, 119, 140, 151, 197
J. Scott Fuqua: 84
Alison George: 66
Jimmy Giegerich: 12

David Gillis: 30
Gustabo: 22
James H. Hosten: 71, 72
Meg Hunt: 82
Alex Innocenti: 25, 129
Sara Jabbari: 115
Tracy Jacobs: 17
Jill Kaczak: 170
Tiffani Krajci: 67
Daniel Krall: 87
Kunisato: 38
Tom La Padula: 86
Max Liebermann: 37
Warren Linn: 13, 92, 120
Sara Lynge: 186, 187

Sam Martine: 197
Andrea Mastroeni: 128
Winsor McCay: 13
Jennifer McCormick: 22
George Thomas Meggitt: 27
Mitra Modarressi: 84
Patrick O'Brien: 142
Erica Ostrowski: 80, 137
Byron Otis: 175
Roberto Parada: 39
Ted Papoulas: 143, 196
Maxfield Parrish: 11
Emiliano Ponzi: 30
Howard Pyle: 81

Rogers, Paul: 36
Kate Talbot: 88, 89, 194
Ronald X. Roberson: 70
Brian Sanders: 10, 118
Greg Spalenka: 11
Deanna Staffo: 21
Boya Sun: 136
Utagawa Toyokuni III: 38
Van Honthorst, Gerrit: 36
Wouter Tulp: 40
Jacqueline Wadsworth: 88, 195
NOTE: All noncredited illustrations by Greg Houston

INDEX